Edward S. Curtis
THE WOMEN

Christopher Cardozo

Foreword by Louise Erdrich
Introduction by Anne Makepeace

Bulfinch Press

New York · Boston

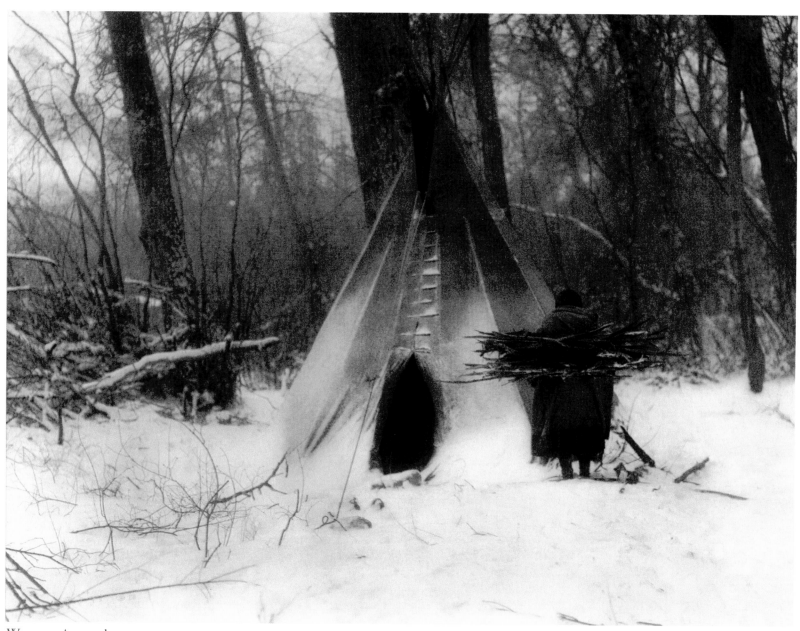

Winter—Apsaroke, 1908

Intensity of Regard

LOUISE ERDRICH

When I look into the eyes of the women photographed by Edward Curtis, there is an exchange, there is intensity of regard. Curtis mastered the art of making his subject so dimensional, so present, so complete, that it is to me as though I am looking at the women through a window, as though they are really there in the print and in the paper, looking back at me. This is the genius and the gift of the work. The women photographed by Curtis are so alive that it seems any minute they will change their expression; the hint of a smile will turn into a hoot or laugh, the frown into exasperation. Just look into the eyes of Klamath Woman, photographed in 1923 (Plate 3). She doesn't quite trust you. The bells on her hat will jingle in just a moment, when she turns away to go about her business.

Although these portraits were posed and painstakingly arranged, the liveliness and the spirit of the women always breathes in the image—the Clayoquot Maiden (Plate 9) is hiding a laugh in her blanket of fur and cedar, the Mohave Mother (Plate 17) nurses her child with offhand dignity. The baby stares with some suspicion at the photographer, but does not relinquish his mother's breast. To me, Curtis' images of women with their children are as disquieting as they are profoundly beautiful. As Anne Makepeace mentions in her essay, these children are shortly to be taken from their mothers and sent to boarding schools run by the United States government. There, they will be stripped of their culture and language. They will cry for their mothers, and their mothers will cry for them. Loss trembles in the background.

Women's work is celebrated in Curtis' photographs—women grind corn, bake bread, make clay vessels, doctor each other, pick berries, haul wood and water, gather reeds, dig clams. These images of women working are among my favorites, for they are more practical than elegiac, yet entirely harmonious, and they are often the most sensual of Curtis' works. His eye lingers on the feel of things, the baked earthen vessels, the clay under the potter's hands as she mixes it, the motion of the reaper, the tensile beauty of a loom set against a canyon wall. There is a flow of energy in these photographs that carries into the present. For although Edward Curtis believed that he was documenting a vanishing culture, it is in these humble arts that the strength of Native culture lives on. Women still make pots using the same techniques and designs. Women still reap crops and harvest rice in canoes. And into their rugs and baskets, their clothing and beadwork, women still weave the sacred symbols of their nations.

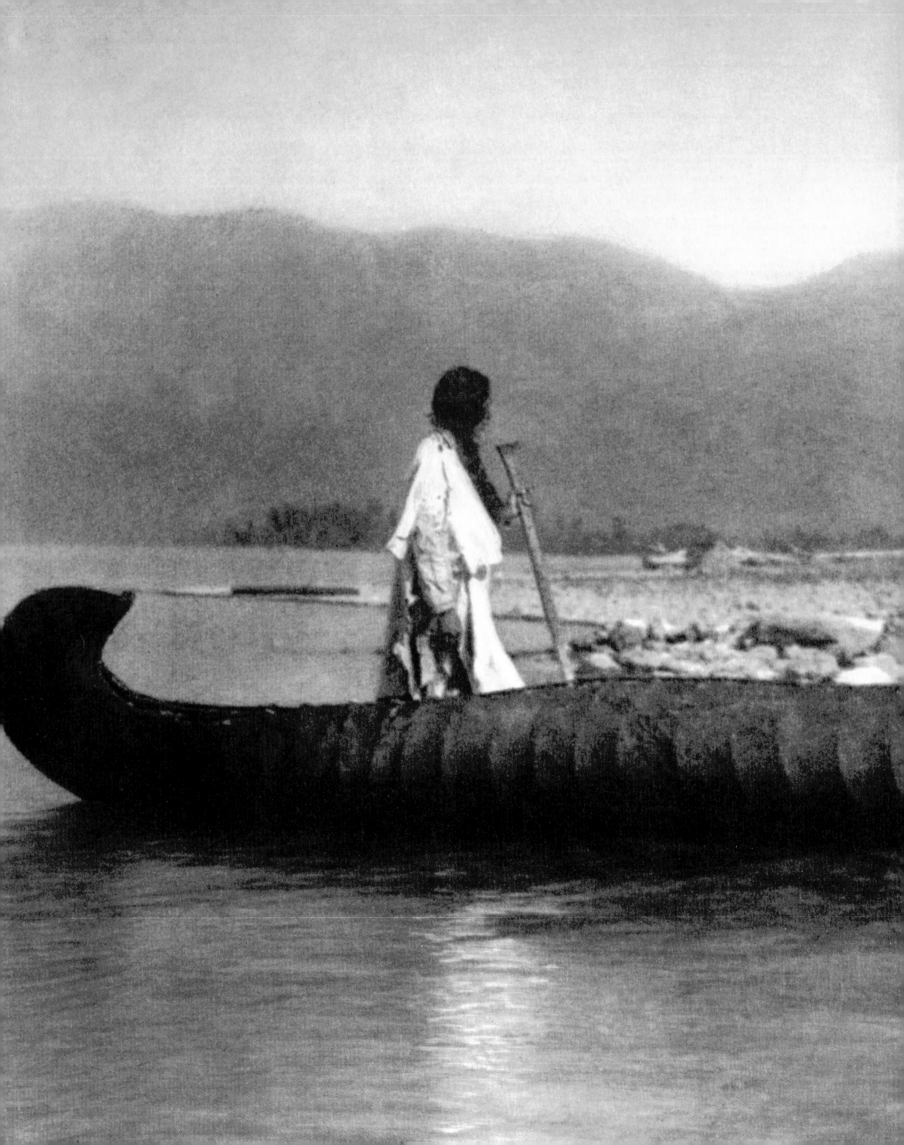

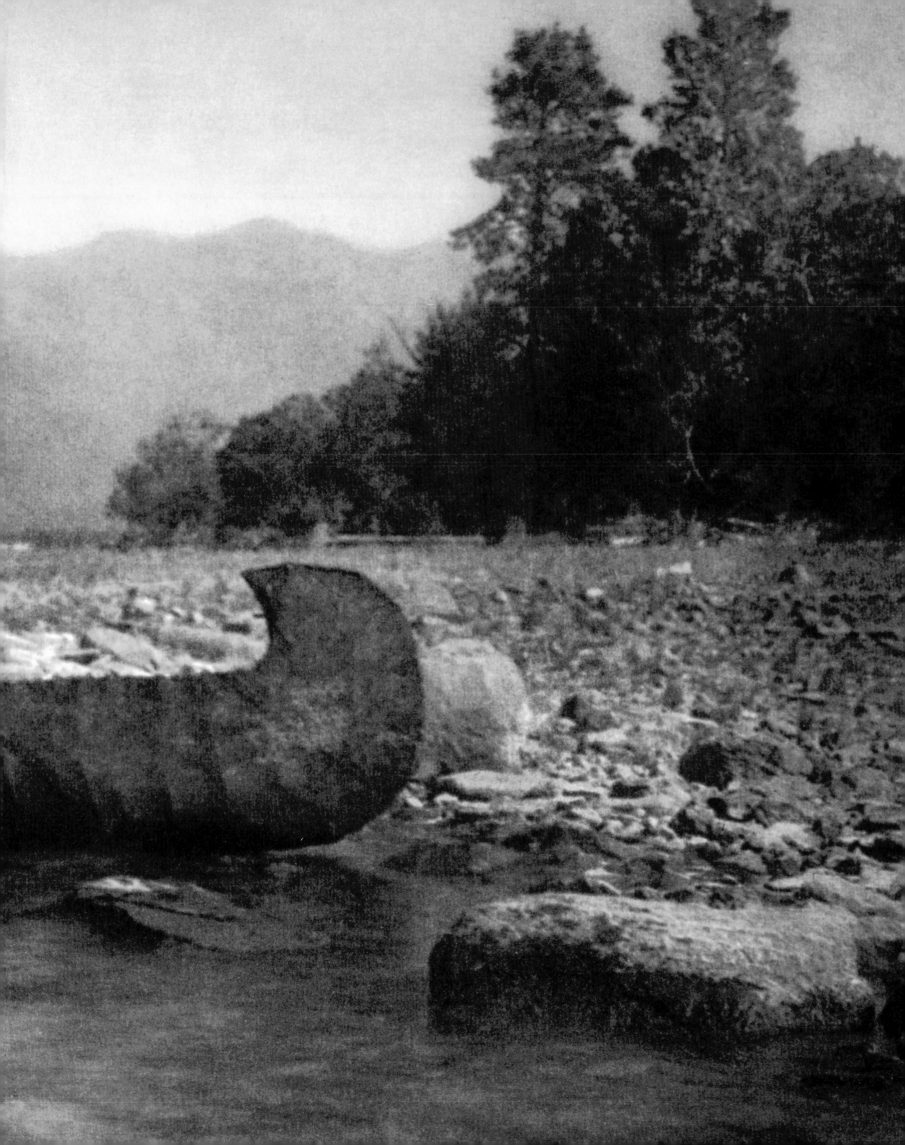

A Broad and Luminous Picture

ANNE MAKEPEACE

To Kickisomlo, the tall man walking across the mud flats toward her must have been a surprising sight. She had been inside the studios of other "shadow catchers," standing before oil paintings of waterfalls and mountains like none she had ever seen in real life. She had watched silently as the shadow catchers hid beneath their black cloths and aimed their black boxes at her, capturing her shadow-image on glass plates, though not her soul. But this man was

Princess Angeline, 1899

carrying his camera over his shoulder, walking across the wet sand as if he belonged there. She turned away and plunged her digging stick into the mud.

When she was a girl, the tide flats and the forests and the vast waters of Puget Sound had been the home of her people. White men had tricked and coerced her father, the great Chief Seattle (Sealth), into giving up this land. They had moved her entire tribe across the sound onto a reservation, and now they wanted to move her there too. She was nearly a hundred years old; this was where she had always lived, and she wasn't going anywhere.

Princess Angeline, as white people called Kickisomlo, was known for her temper. Edward Curtis had heard that when the sheriff threatened to evict her from her cabin, she threw clams through his windows. Curtis planted his camera a little ways off and took out his glass-plate negatives, but the old woman gestured for him to go away. Instead he walked over and asked her to show him what she was doing. With his charm, his humor, his sincere interest, and a little bit of cash, he soon won her over.

This is how I imagine it all began. Fifty years later, Curtis wrote: "The first photograph I ever made of Indians was of Princess Angeline, the digger and dealer in clams. I paid the Princess a dollar for each picture I made. This seemed to please her greatly and with hands and jargon she indicated that she preferred to spend her time having her picture made than in digging clams."

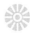

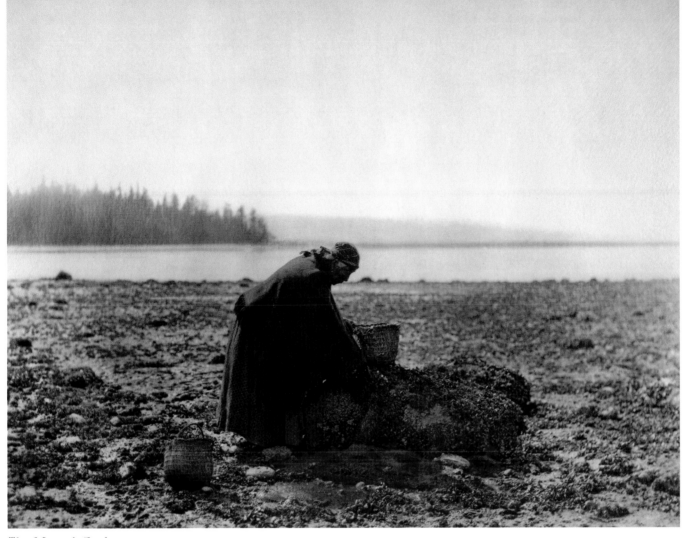

The Mussel Gatherer, 1900

In 1895, Edward Curtis was twenty-seven years old and rapidly becoming the most successful society photographer in Seattle. Just four years earlier, he himself had been digging clams on a homestead across the sound, and taking day labor jobs to support his family. In 1891 he had moved to Seattle and bought a partnership in a photography studio downtown, where he quickly became famous for his portraits of brides, society children, and Seattle's leading citizens. He often escaped from the din of the city streets to photograph along the tide flats of Puget Sound.

Curtis knew instinctively how to inspire trust in his photographic subjects. When asked late in his life how he was able to gain the confidence of Indian people, he wrote, "I said we, not you. In other words, I worked with them not at them." He captured many beautiful images of Princess Angeline near her cabin on the sound. Two of them, *The*

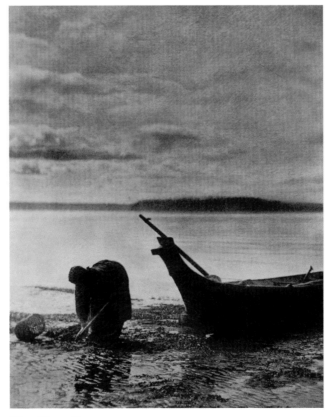

The Clam Digger, 1899

7

Mussel Gatherer and *The Clam Digger,* were chosen for an exhibit sponsored by the National Photographic Society in1898. "As a loan exhibition it traveled over a good part of the civilized world. Naturally I was quite proud of myself and the pictures." One of his photographs won the exhibit's grand prize, and a gold medal.

Unlike the Indians Curtis saw along skid row or out on the reservations, Angeline was living close to the old ways she had known as a child. He admired her resilience, her sly humor, and her intransigent refusal to leave her homeland. With her death in 1896, he began to realize, as he would later write: "The passing of every old man or woman means the passing of some tradition, some knowledge of sacred rites possessed by no other; consequently the information that is to be gathered for the benefit of future generations, respecting the mode of life of one of the great races of mankind, must be collected at once or the opportunity will be lost for all time."

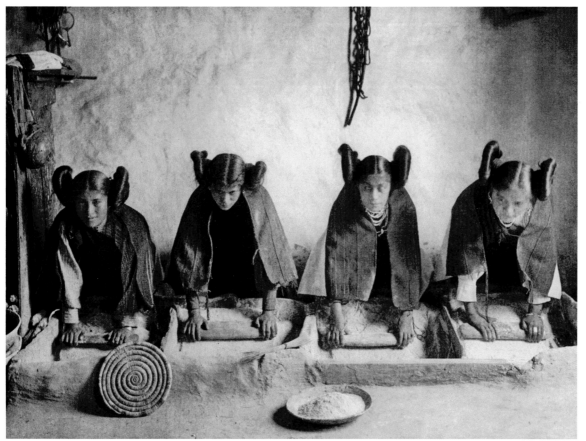

Grinding Meal—Walpi, 1922

This vision of a passing world would change Curtis' life, uproot him from his home, and send him on an Odyssean journey that would consume him for the next thirty years. Between 1900 and 1930 he traveled from Mexico to the Arctic, from the Rockies to the Pacific, photographing and recording more than eighty tribes. He created an astonishing body of work: forty thousand photographs, the first full-length ethnographic motion picture, ten thousand wax cylinder recordings, twenty volumes of ethnographic text with accompanying portfolios, and several books of Indian stories. He sacrificed his home, his marriage, and finally his health in his determination to accomplish his goal of recording in pictures, text, and sound, every tribe still practicing the old ways. Against all odds, he succeeded in creating "a broad and luminous picture," the most comprehensive record of traditional American Indian life ever made.

My own journey with Edward Curtis began in 1991, when I set out for Arizona to begin research for a dramatic feature film I was writing about his life. I planned to structure the film around his experiences on the Hopi reservation, where he had returned year after year between 1900 and 1921, and where for a time at least, he left the camera behind to participate in the religious life of the tribe.

I intended to start my film with an ancient Hopi woman remembering Curtis' arrival when she was a child, the strangeness of this man with a wooden box for a head, lenses for eyes, a black cloth around his neck. I wanted to meet

elderly Hopi women, to listen to their voices, learn about their beliefs, and to hear about their first experiences of white people coming to the reservation. But first, I had to get permission to do research at Hopi from the director of the Office of Cultural Preservation. I had arranged an appointment weeks before, but when I arrived at the tribal offices, he had left for the weekend.

Reeling with hunger and disappointment, I headed to Second Mesa and the Hopi Cultural Center. As I was about to enter the restaurant there, I noticed a sign next to the museum: "Elders Lunch, All Welcome, $3.50." Right there in front of me was a whole table of women elders, laughing and talking, beckoning to me and calling, "Come in!" "Come eat!" Here they were, the Hopi women I had been looking for, whose voices would enter me like music and become part of my own story.

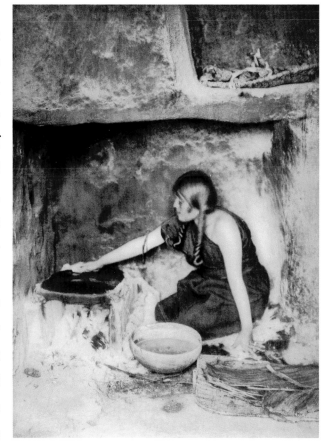

The Piki Maker, 1906

I joined these women for a bowl of Hopi stew, a thick soup filled with mutton and hominy served with thin blue corn pancakes called piki, washed down with Koolaid. I showed them some of Curtis' Hopi photographs, and they were fascinated by them. They laughed over Curtis' image of Hopi girls grinding meal, pointing out that the girls would never have worn their wedding dresses for this messy task, and they certainly wouldn't have been getting married all on the same day. Clearly Curtis had asked them to dress up for the occasion, and these women thought that very funny.

My new friends suggested other women I should talk to who might recognize their relatives in the pictures. In the tiny village of Walpi, I found Ethel Mahle, bright eyes blazing from her ancient face. She looked carefully at each picture I showed her, and when she came to *The Piki Maker,* she beamed at me and exclaimed, "That's my mother making piki!" She told me that her mother's name was Dayumana, "Fox Girl," and that she used to make the thin, rolled blue corn pancakes called piki to sell to tourists. Later Ethel told me many stories about her; how Dayumana killed a porcupine with a shovel and served it for dinner, how she joined the Baptist church because the Christians had food.

These stories and those of others I met that year made me see Curtis' photographs in an entirely new way. The iconic image of *The Piki Maker* was transformed into a photograph of a single mother struggling to make sense of her world at a time of terrible transition, to feed her family, to make a little money posing for a picture. The pictures became infused with the emotional weight of real life, adding a new and complex tension between the beautiful images Curtis created and the realities of people's lives.

Two Hopi women in Curtis' photographs were still living then, Zella Cheeda and Sunbeam Poncho. With my Curtis book in hand, I knocked on Sunbeam's door, and a tiny white-haired woman in her nineties opened it and asked

me in. She had a postcard of *At the Trysting Place,* on her refrigerator, and proudly pointed to herself, the young girl on the right side of the photograph. When I told her what "trysting" meant, she laughed and said no, they weren't meeting their boyfriends there, not that time. Her cousin Garnet had come running to tell her that a *pahana* wanted to photograph them. He was looking for girls who still had hair long enough to put up on the beautiful butterfly whorls. It was 1921, one of Curtis' last visits to Hopi, and by then all of the girls in the village had been forced to cut their hair off at the Keams Canyon boarding school. The beautiful butterfly whorls had all but disappeared. Sunbeam told me that she and Garnet had contracted tuberculosis at school and had been sent home. Their hair had grown long again, and when they had recovered from their illness, they refused to go back or to cut their hair. Curtis took them to an isolated spot where young couples often met, and took picture after picture of the two shy girls. Some fifty years later, a friend had sent Sunbeam this postcard. It was the first time she had seen the picture.

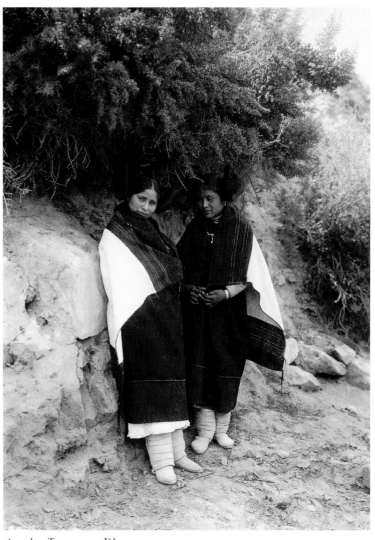

At the Trysting Place, 1921

Zella Cheeda was ailing in a nursing home in Winslow, Arizona, but she lit up when she saw the pictures. She named every place in the photographs: the springs, the kivas, the houses, villages, trails and gardens. She laughed when she described the day she and her friends had spent with the *pahana* photographer, Edward Curtis, more than seventy years before. First, their mothers had to put their hair up in traditional butterfly whorls and tie on their "atoo's," which they normally wore only for very special occasions. Then Curtis took the group all around the mesa: to the spring where they filled jars with water; to the housetops where he told them to gaze off into the desert, but the most memorable scene was when they had to grind corn. They found looking at the camera while trying to grind corn so ridiculous that they couldn't stop laughing, annoying Curtis, which only made them laugh harder. This was the picture that had so amused the women at the Cultural Center.

My experiences at Hopi made me see Curtis' photographs in a new way, and transformed my vision for the film. I began to see his photographic subjects as people who had not vanished, but who had managed to survive against all odds, holding tenaciously to traditions while at the same time learning to adapt to modern life. And I discovered that their descendants are still carrying on these traditions in many ways, some inspired by Curtis' pictures. Hundreds of descendants of the great potter Nampéyo, who revived Hopi pottery at the turn of the last century using designs from shards she found buried near her home on First Mesa, are now famous potters in their own right. Navajo weavers have based patterns on Curtis images, as have medicine men and women learning sand painting designs. At the Suquamish reservation on Bainbridge Island, Pegi Deam remarked that "there are so many things locked up in Curtis' images" that she and her people are learning from. She herself is weaving traditional outfits based on clothes worn by women in his pictures, and she is also designing a traditional long house on her computer with the help of a Curtis photograph.

In making the documentary film about Curtis that would become *Coming to Light,* I interviewed hundreds of Indian people from tribes ranging from Arizona to Alberta, from Seattle to the Bering Sea, and it was always the women who told me the most revealing, most heart rending, and also some of the funniest stories about their ancestors in Curtis' photographs, and about the white man who came to photograph them. Mary Everson, daughter of the woman who played the heroine Naida in Curtis' great 1914 film *In the Land of the Head Hunters,* told hilarious stories of Curtis' direction going awry, sending the huge war canoes into rocks and giving the community of Fort Rupert endless entertainment as he tried again and again to get his shot. Eloise White Bear Pease told of Curtis' visit to her cabin on the Crow reservation in 1907 when she was four years old, of how he made her usually solemn mother laugh as he recorded their voices on wax rolls.

In 1998 I interviewed the great-great-great-granddaughter of Kickisomlo at her home near Tacoma. As she gazed at the photographs, she became very emotional: "I wish I could have met her. I probably would have understood myself a little better. I think these pictures will give my grandchildren an appreciation of what our ancestors went through. Just looking at their faces, you know they must have had a really hard life. I would hope they would come away with a respect for people who really fought to keep what they had in a time when it was very difficult. That is why I tell my people, get in touch with who you really are. Learn about your past. Then you'll know why you do things in a certain way, why you feel a certain way about something. Our ancestors are still here with us, and not just in these pictures."

Curtis had great respect for American Indian women, and the connection he made with them is evident in the photographs in this volume. As you turn these pages, look carefully at the intricately woven designs in their clothing, at the way they look at their children who will soon be taken from them and sent to boarding schools. As they gaze into Curtis' lens, some of the women seem to be asking him, what will become of us? Will our children see these pictures and know us as we were? Still others stare boldly at the camera, their proud expressions declaring, "This is who I am. This is who I will be."

Enduring Beauty

CHRISTOPHER CARDOZO

Edward Curtis was a renaissance man whose accomplishments were both extraordinary and unprecedented. He lived through a period replete with profound and dramatic changes. Only three years before his birth, the Civil War ended and the slaves were finally freed. Yet by his death in 1952, atomic energy had been harnessed, television was in its infancy, and the United States had become the world's dominant economic and political power. Photography had also been radically transformed from a slow, demanding, and expensive process practiced by few, to a broadly available medium with a wide variety of styles, methods, and techniques.

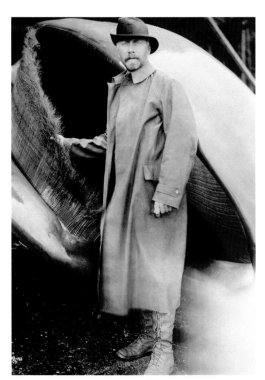

Untitled (Curtis with Whale), 1914

Curtis was born in 1868 in rural Wisconsin. His father was an impoverished itinerant preacher in failing health. The family soon moved to Minnesota where Curtis often accompanied his father on trips to visit his far-flung congregation. Although his family often subsisted for weeks on a diet of potatoes (supplemented only occasionally by muskrat meat), Curtis, at twelve, managed to scrape together a small amount of money to build his own camera and purchase a manual explaining the technical elements of the photographic medium. This early beginning of Curtis' photographic career was auspicious, as evidenced by the seeds of the strong will, drive, and individualism that would be hallmarks of Curtis' adult life.

Inspired by photography, the young Curtis began to focus his energies on hands-on practice and experimentation as well as studying the theory of photography. By age seventeen, Curtis had moved to St. Paul, where he apprenticed in a photographic portrait studio. Curtis became fully versed in the fundamentals of the medium and the aesthetics of studio portraiture, an aspect of photography that became central to his later success.

By 1887 Curtis' father's health had worsened and the family moved to the temperate climate of the Pacific Northwest. The stresses of the move further weakened Reverend Curtis' fragile health and he died shortly thereafter. Curtis had to abandon his budding photographic career to assume the primary responsibility of supporting his family. However, within five years Curtis was able to secure a loan by using the family's only asset, their homestead, as collateral in order to purchase an interest in a small photographic studio in Seattle. Within a few years he bought his partner out, firmly established his photographic business, and soon married and began a family.

By 1896, Curtis was Seattle's pre-eminent portrait photographer. This newfound financial success gave him the freedom to pursue his great love of the outdoors. It was most likely during these field trips that Curtis first began to encounter Native Americans whose culture was still somewhat intact. Early Curtis photographs of

traditional Native American life soon attracted critical attention, and by 1898 Curtis began receiving important national prizes for his work. That same year, Curtis was on one of his frequent mountaineering expeditions when he happened upon and rescued a lost group of climbers. Among them were several luminaries from the East Coast establishment. This chance encounter led to Curtis' invitation to become the chief photographer for the last great scientific expedition of the 19th century.

The Harriman Expedition of 1899 not only introduced Curtis to some of the country's foremost scientists and to serious scientific methodology, but also cemented his friendship with George Bird Grinnell, a seasoned anthropologist known as "The Father of the Blackfeet." The friendship led to an invitation to accompany Grinnell, in the summer of 1900, on an expedition to visit the Blackfeet and Piegan tribes in Montana. This two-week trip to Montana was a watershed experience that profoundly and inextricably altered the course of Curtis' life. It was during this expedition that he first experienced significantly intact Indian culture, witnessed soon-to-be-outlawed rituals, and was privy to the Indians' personal histories and religious beliefs. Curtis realized that what he was witnessing was rapidly disappearing and that he was in a unique position to create a record of the Indian people. Curtis was deeply impassioned and imbued with a great sense of urgency. Thus began Curtis' great adventure, which over the next thirty years resulted in the creation of the most ambitious anthropological project ever undertaken by one man.

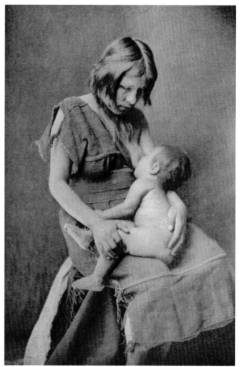

A Hopi Mother, 1922

To accomplish this, Curtis needed the help of many people. Principal among them were President Theodore Roosevelt and financier J. Pierpont Morgan. Curtis came to President Roosevelt's attention after winning a national portrait contest in 1903. Curtis and Roosevelt became fast friends and Curtis was a frequent guest at the Roosevelt retreat at Oyster Bay on Long Island. A great believer in Curtis and his mission, Roosevelt wrote a glowing letter of introduction that Curtis used to make the acquaintance of the world's wealthiest man, J.P. Morgan.

In the fall of 1906, Curtis had a fateful meeting with the demanding, no-nonsense Morgan in his imposing Wall Street offices. Upon hearing Curtis' proposal, Morgan quickly rejected the possibility of his financial assistance. Curtis, rather than backing down, convinced Morgan to look at a small portfolio of his Native American photographs. Morgan immediately changed his mind and agreed to underwrite several years of the field research and photography in exchange for a substantial body of the work that Curtis was to create in book form. Thus was born Curtis' magnum opus *The North American Indian,* a twenty volume, twenty portfolio, set of hand-made books, which, in today's dollars, cost approximately thirty-five million dollars to create.

Unfortunately, receiving Morgan's money turned out to be a double-edged sword, for it gave Curtis enough money to begin the ambitious project but not nearly enough to finish it. Originally slated to take five years, in actuality it took nearly a quarter of a century to complete. Despite financial panics, World War I, unfounded attacks from a few jealous anthropologists, and soaring costs for both the fieldwork and production, Curtis managed to finish his project just months after the country sank into the Great Depression. The final product, *The North American Indian,* remains to this day an unparalleled achievement. Each set of these now rare books comprises thousands of pages of detailed anthropological text, transcriptions of language and music, and most importantly, over 2,200 original

photographs of more than eighty tribal groups spread out over a million square miles in the western United States, Canada, and Alaska. The vast majority of the photographs in this book are drawn from those rare volumes.

Edward Curtis created an evocative and unique visual record of North American Indian women. His first Native American subject was a woman, Princess Angeline, the daughter of Chief Seattle. While Curtis is better known for his male portraits, the surviving body of Curtis' work contains hundreds of images of Native American women. My research leads me to believe that Curtis has made between 6,000 and 10,000 negatives wherein Native women were an important element of the image. This number is all the more impressive when one thinks not only of the logistic hurdles Curtis had to overcome, but also the great resistance among Native peoples of that era to being photographed. This resistance was especially strong among Native women. The reason that awareness of Curtis' female portraiture is not greater is due principally to the fact that he photographed significantly more males, and many of them were famous warriors or tribal leaders. In addition, the intense male portraits more deeply reflect modern culture's archetypes of Native Americans (indeed some would say actually helped create them). In contrast, Curtis' female portraits are far less frequently identified as individuals, and females were singled out for tribal recognition far less commonly than men.

Curtis often included water imagery in his female portraits, as an aesthetic reference to their softness and femininity, which served to present a gentler and less dramatic portrait than those of the chiefs and braves. The female portraits also evidence more variation and nuance than the male portraits, and women are depicted in a much greater variety of activities. The women are shown engaged in the making of arts and crafts, food gathering and preparation, gathering water, child rearing, ceremonial rituals, and so on. The fact that Curtis was able to photograph Indian women so frequently, in such a variety of situations and activities and often with great intimacy, is a testament to his strong relationship with Native Americans and the great trust they placed in him. That trust, as well as the message and feeling he was trying to convey, is clearly evident in the photographs of Native women reproduced in this book.

When looking at Curtis' photographs of Native American women, a number of his themes become apparent: First, there is the classic close-up portrait (see cover and Plate 61). Curtis also frequently photographed women carrying pots or baskets on their heads. These two portraits (Plate 27 and Plate 61) exemplify this theme. Mothers with young children are another very common theme, as is illustrated on page seven by the little known photograph *A Hopi Mother* as well as in numerous images reproduced throughout this book. Curtis also extensively photographed women in the landscape. Sometimes the women themselves were the primary focus, while at other times the landscape was prominent with the women playing a minor role. Curtis often photographed women

with the intention of depicting an archetypal activity or role. For instance, he frequently photographed everyday work activities, as in *The Wood Gatherer* shown below. Additionally, Curtis photographed women engaged in various aspects of making pottery and baskets. The seldom seen images *The Pottery Burners,* 1927, and *The Piki Maker* (Plate 88), are excellent examples of these ideas.

As you peruse the photographs in this book, you will be struck by the cultural, geographic, and physical diversity among the women themselves. It is important to remember the tremendous differences in geography and climate among these native women's environments when trying to grasp their great diversity. A number of the women shown here lived sedentary lives in the Southwest Desert, where the annual temperatures ranged from temperate to hot, and food, water, and material resources were generally scarce. At the other end of the spectrum, many women of the Northern Plains were semi-nomadic, and had to endure extremely harsh winters of sub-zero temperatures in an environment where game, water, and food were often plentiful. Women on the Northwest Coast, by contrast, lived in relatively temperate weather year round and had a great abundance of food and material resources. These vast differences in climate, food availability, and resources no doubt explain differences in the clothing and other elements of material culture the women exhibited. Also, because various groups migrated to North America at different times and settled in different areas, one can frequently discern distinct physiological differences (for instance, if one compares the Asiatic influenced physiognomies of the Pacific Northwest with the faces of the Great Plains, clear differences are apparent).

This volume, the first devoted exclusively to portraits of native women, will give the reader a greater sense of this unexplored area

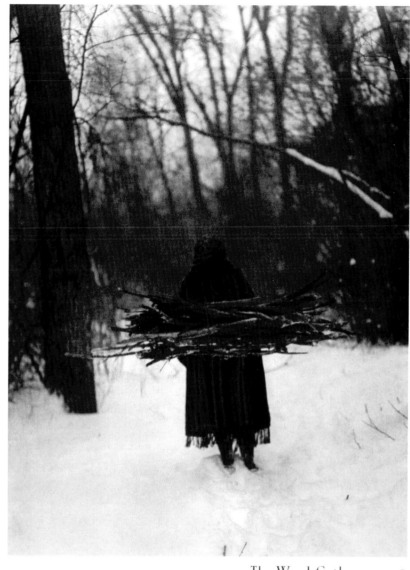

The Wood Gatherer, 1908

of Curtis' work. After spending time with this book, you will not only have a greater awareness of the depth, breadth, and beauty of Curtis' work, but even more importantly, a greatly enhanced sense of the beauty, diversity, and presence evidenced in the Native women Curtis photographed during this prolific thirty-year period. Curtis' work has deeply permeated this nation's perception of Native Americans a hundred years ago. To create this monumental work, Curtis sacrificed his family relationships, his health, and his financial stability. However, despite extraordinary odds and nearly insurmountable obstacles, he managed to create and preserve a unique record of the American Indian that may well endure for centuries to come.

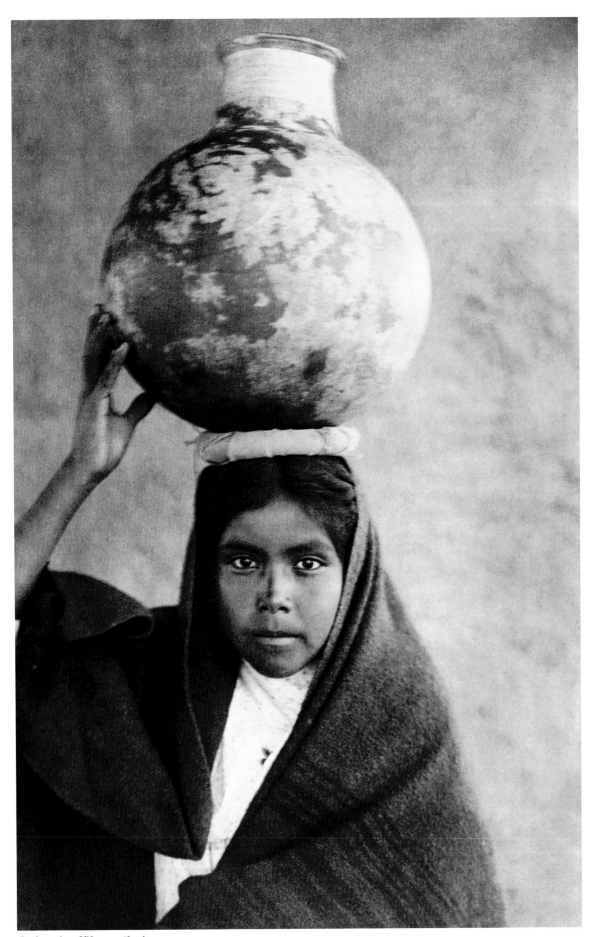

Qahatika Water Girl, 1907

PLATES

The spirit of the Native people, the first people, has never died. It lives in the rocks and the forests, the rivers and the mountains. It murmurs in the brooks and whispers in the trees. The hearts of these people were formed of the earth that we now walk, and their voice can never be silenced.

—Kent Nerburn

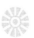

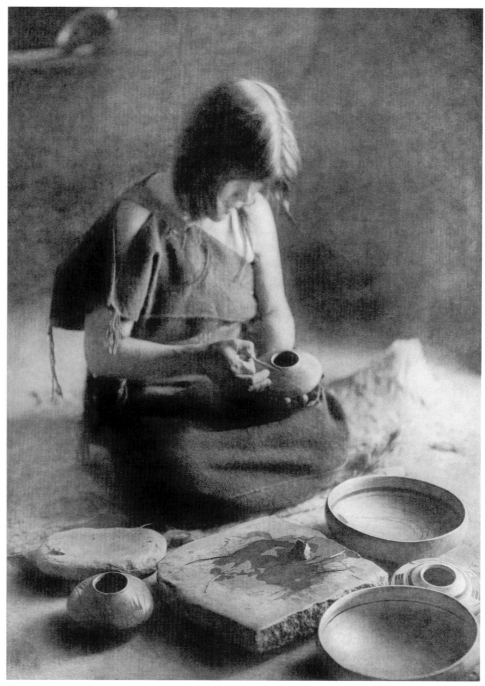

The Potter—Walpi, 1906 Plate 1

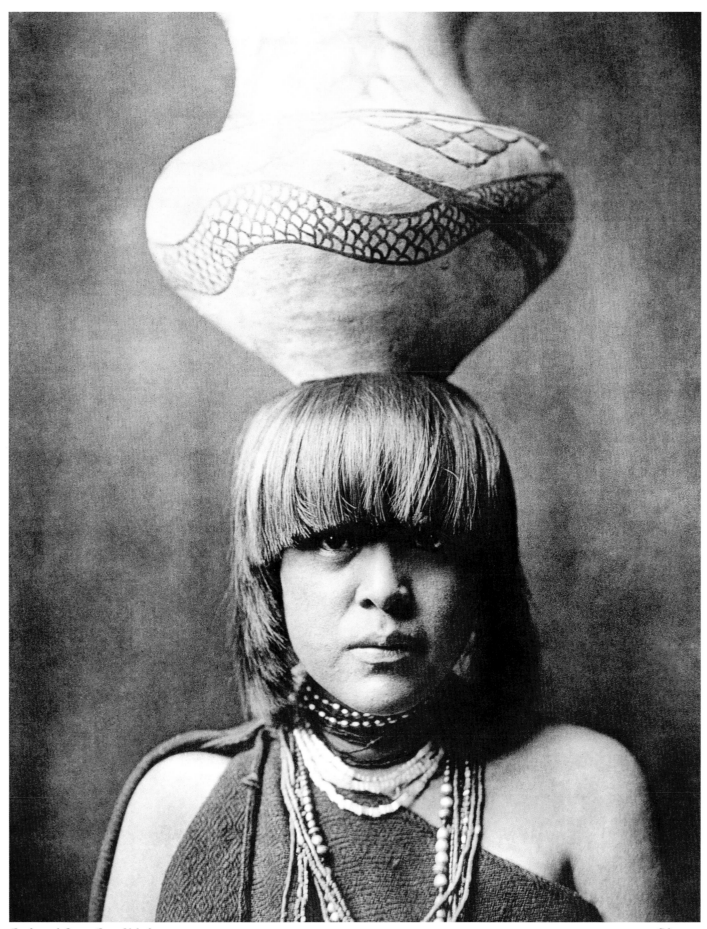

Girl and Jar—San Ildefonso, 1905 Plate 2

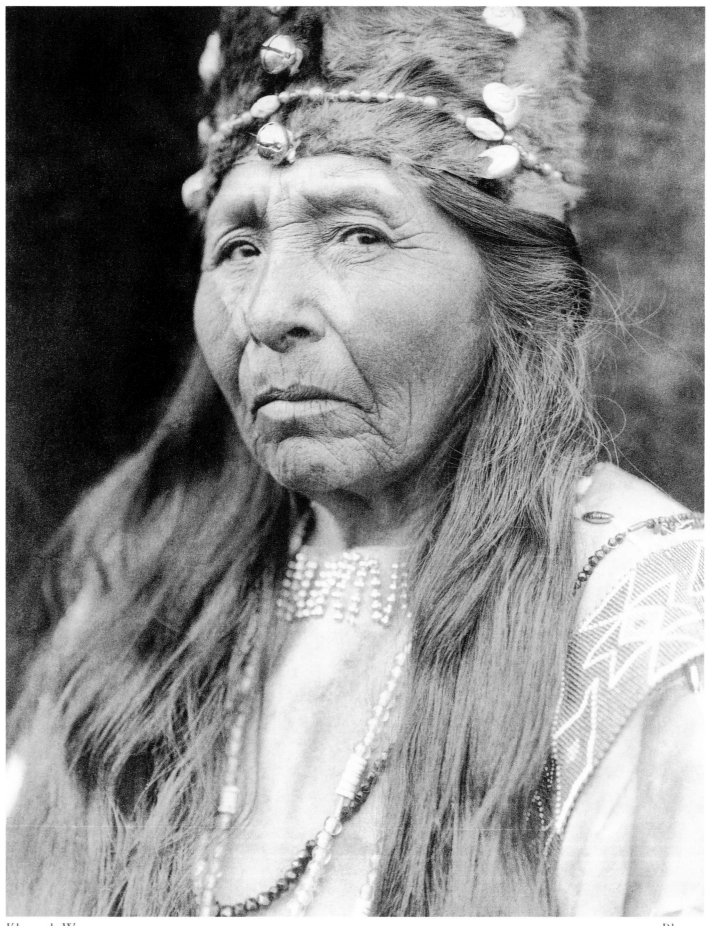

Klamath Woman, 1923 Plate 3

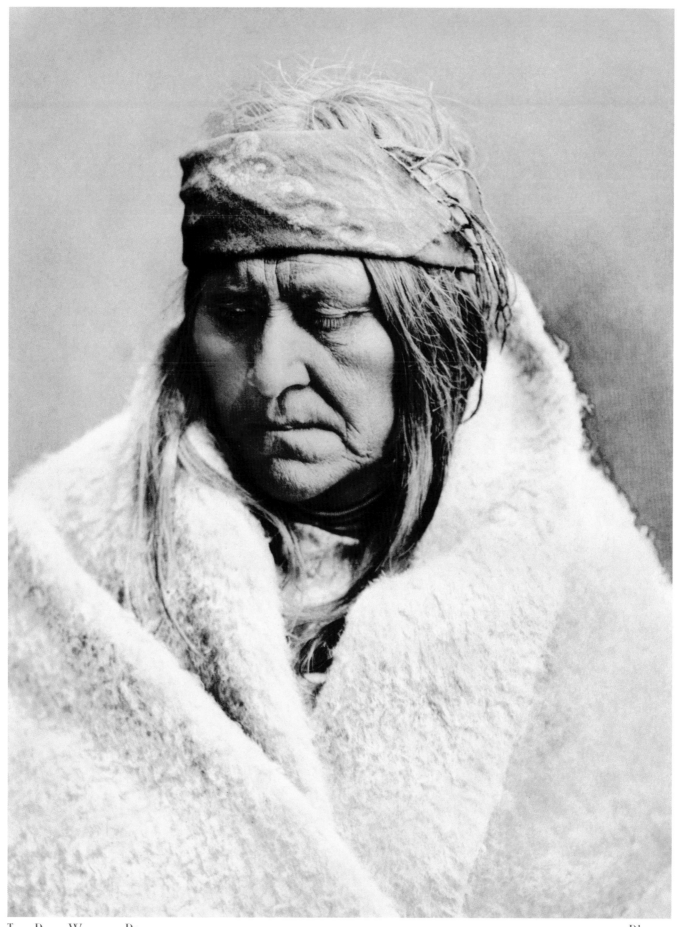

Two Bear Woman—Piegan, 1911 Plate 4

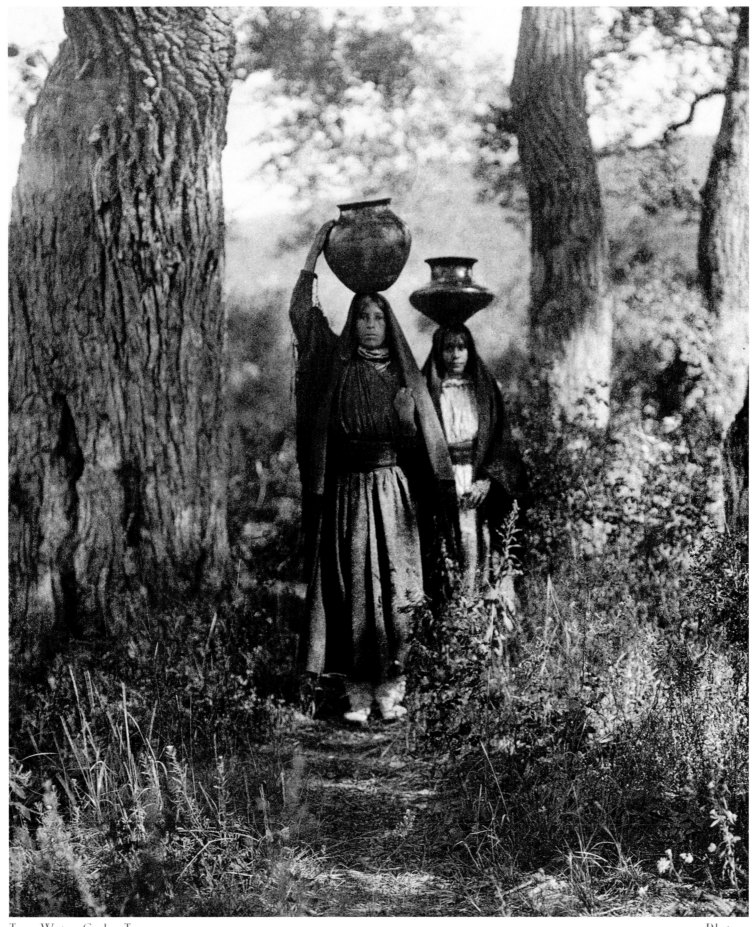

Taos Water Girls—Taos, 1905 Plate 5

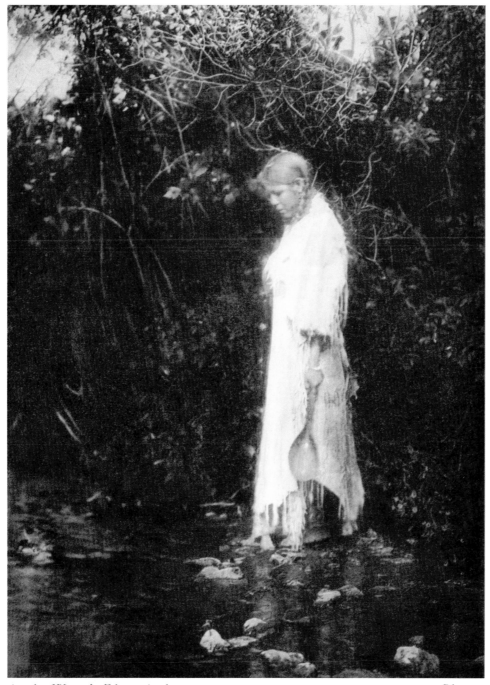

At the Water's Edge—Arikara, 1909 Plate 6

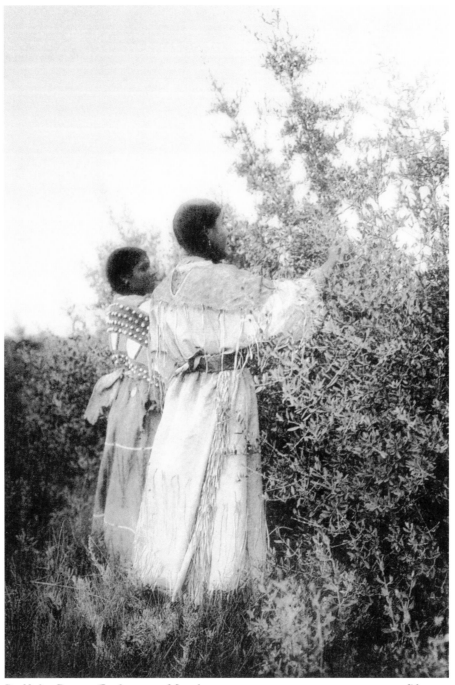

Buffalo-Berry Gatherers—Mandan, 1909 Plate 7

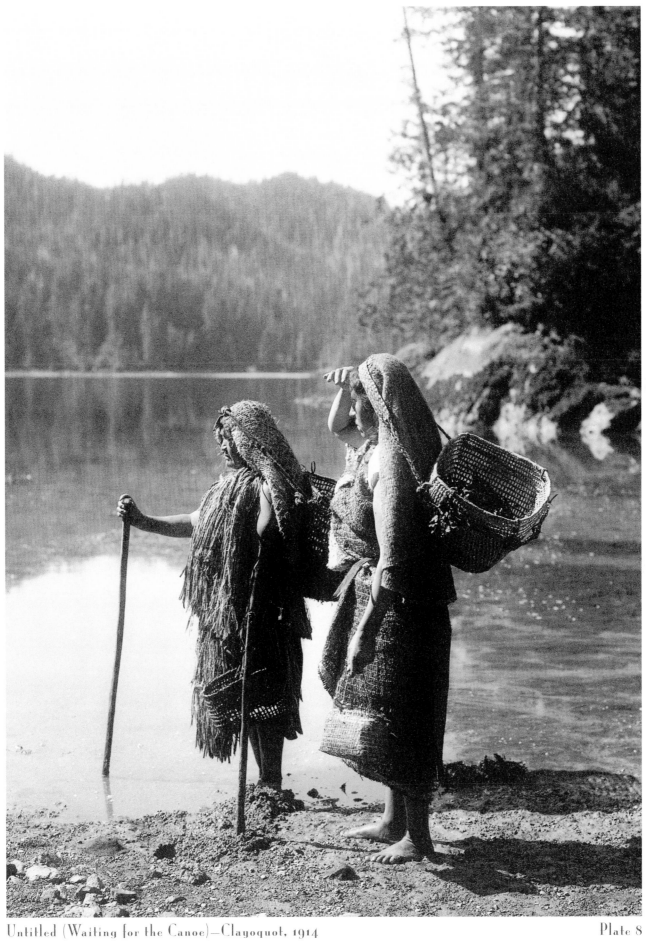

Untitled (Waiting for the Canoe)—Clayoquot, 1914 Plate 8

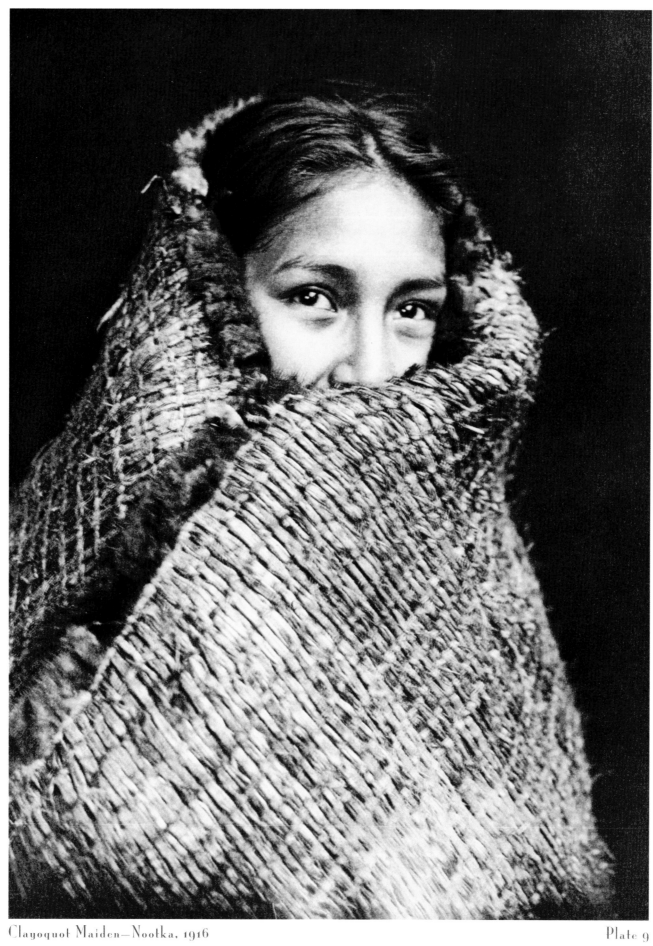

Clayoquot Maiden—Nootka, 1916 Plate 9

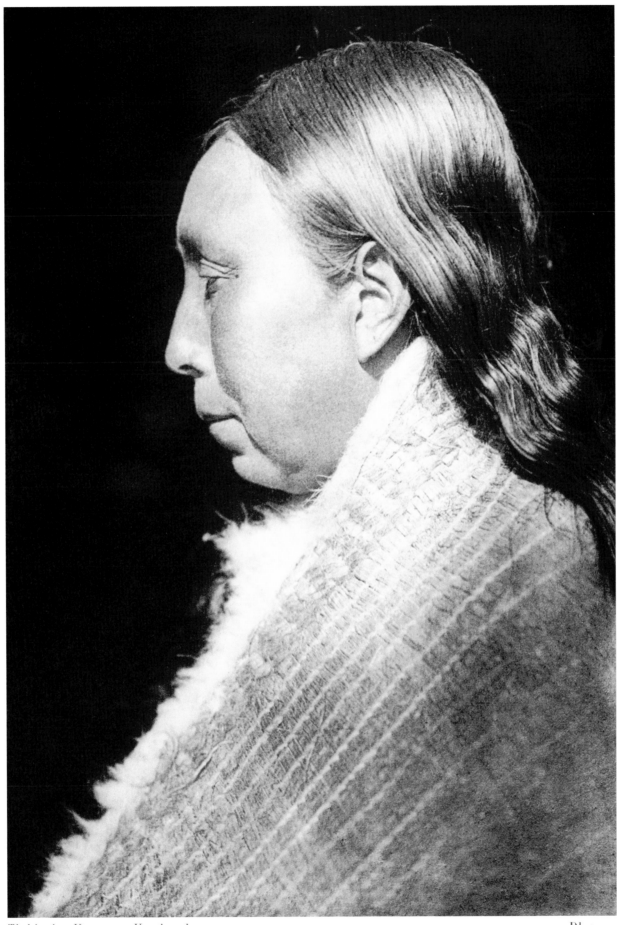

Tlahleelis–Koprino–Kwakiutl, 1915 Plate 10

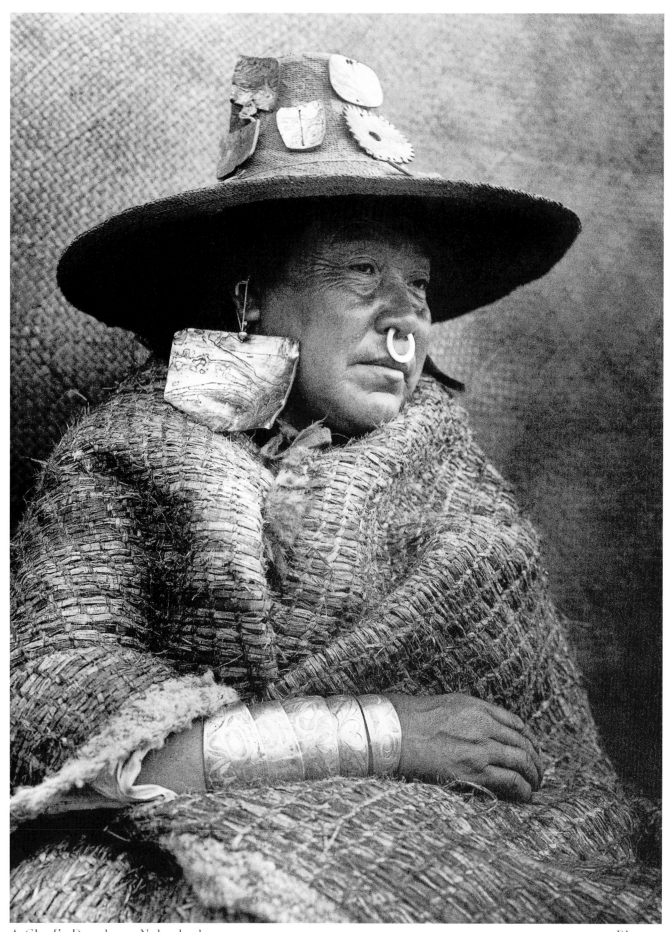

A Chief's Daughter—Nakoaktok, 1914 Plate 11

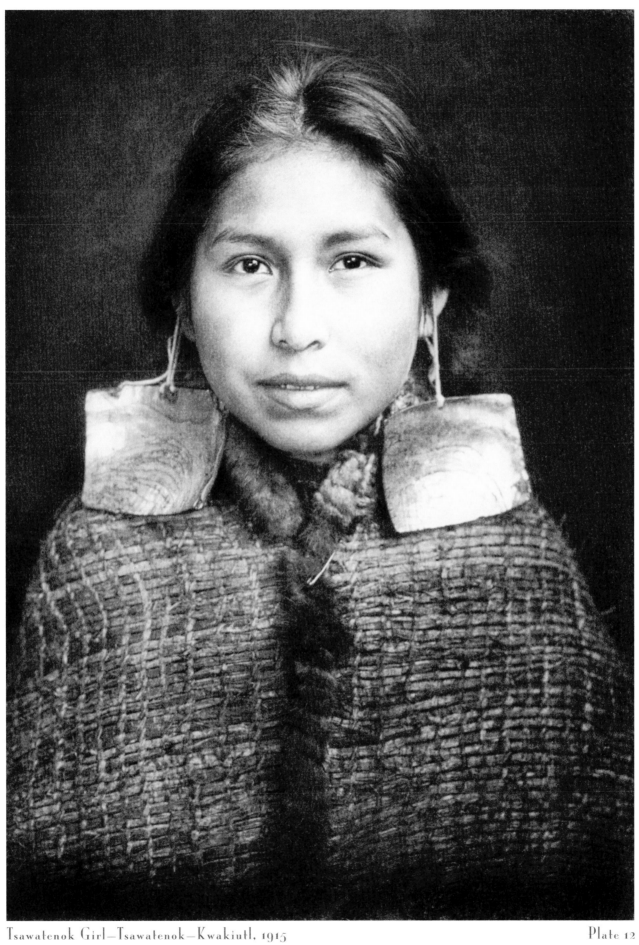

Tsawatenok Girl—Tsawatenok—Kwakiutl, 1915

Plate 12

What is life?

It is the flash of a firefly in the night,

It is the breath of a buffalo in the winter time.

It is the little shadow which runs across the grass

and loses itself in the sunset.

—Crowfoot (Blackfeet), 1919

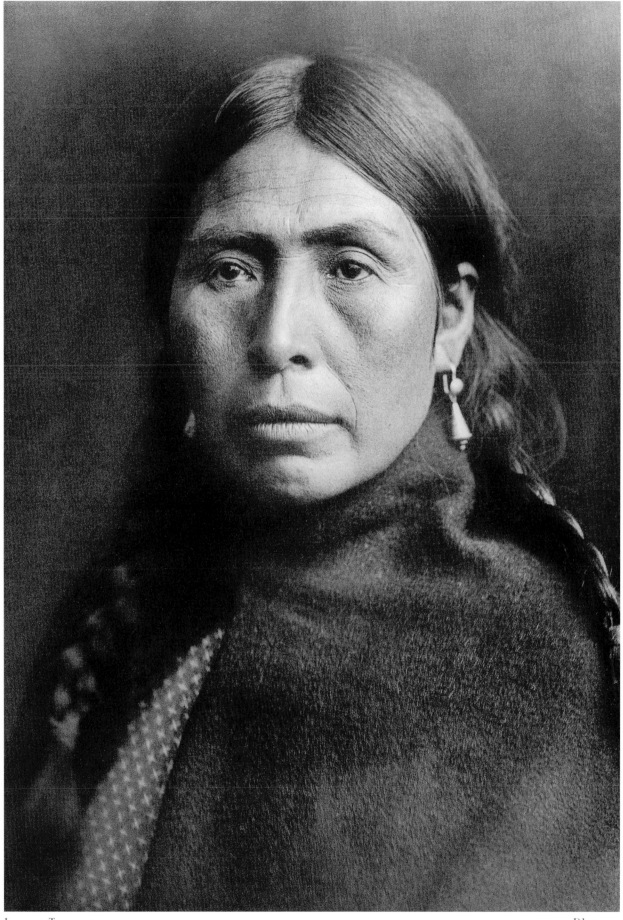

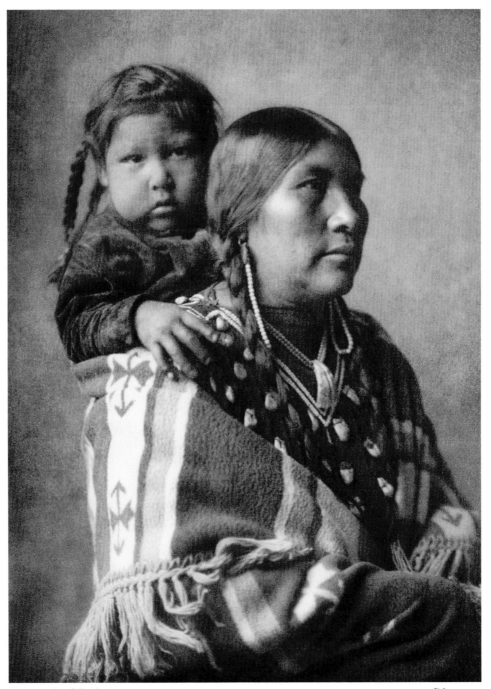

Apsaroke Mother, 1909 Plate 14

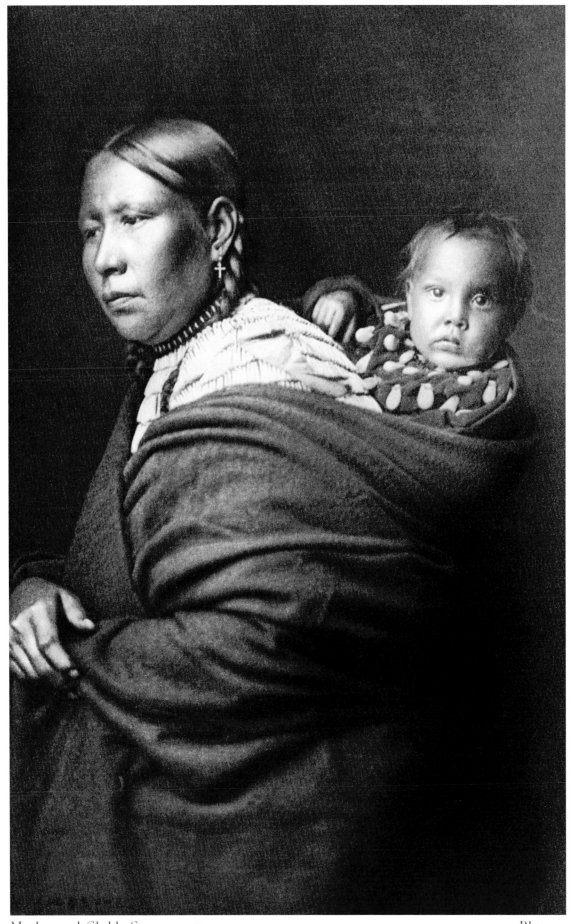

Mother and Child—Sioux, 1908 Plate 15

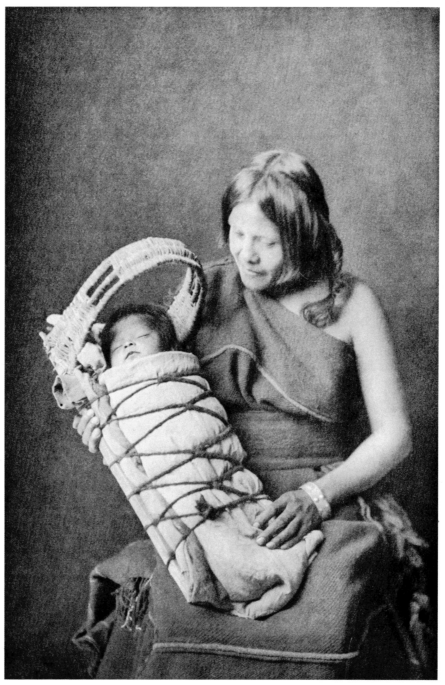

In the Cradle-Basket—Hopi, 1922 Plate 16

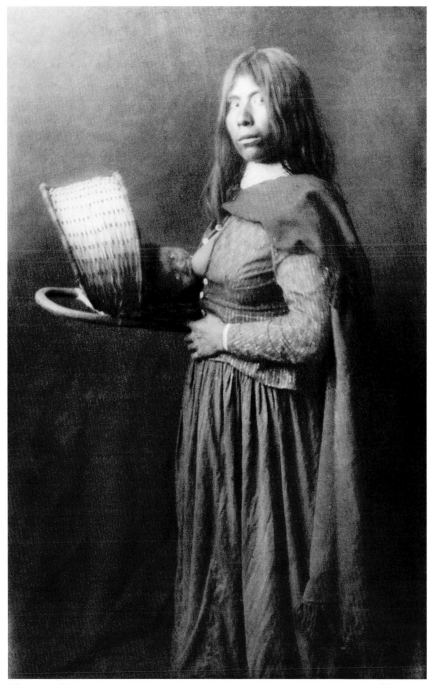

Mohave Mother, 1908 Plate 17

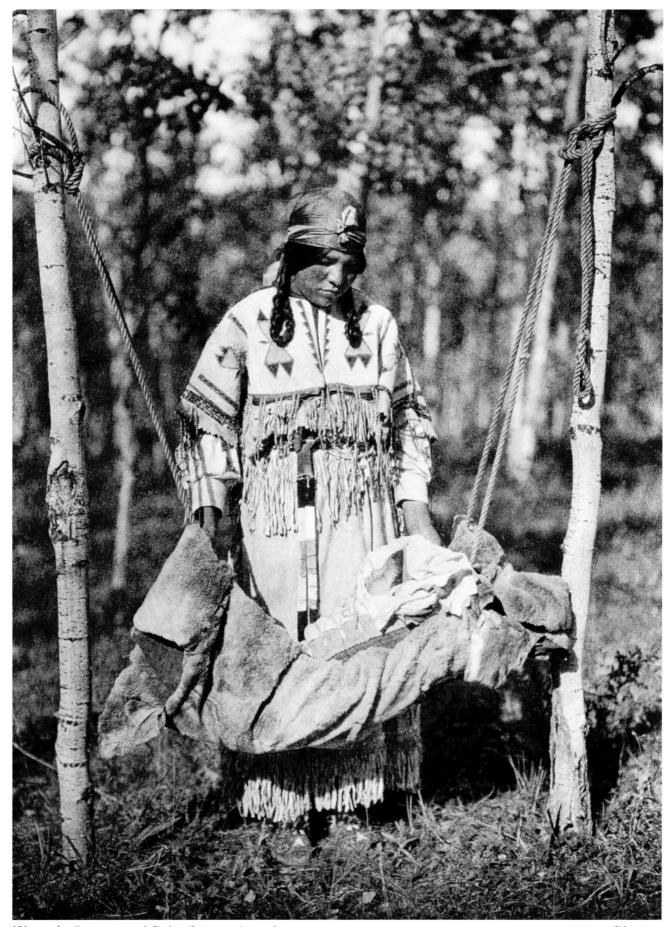

Woman's Costume and Baby Swing—Assiniboin, 1928 Plate 18

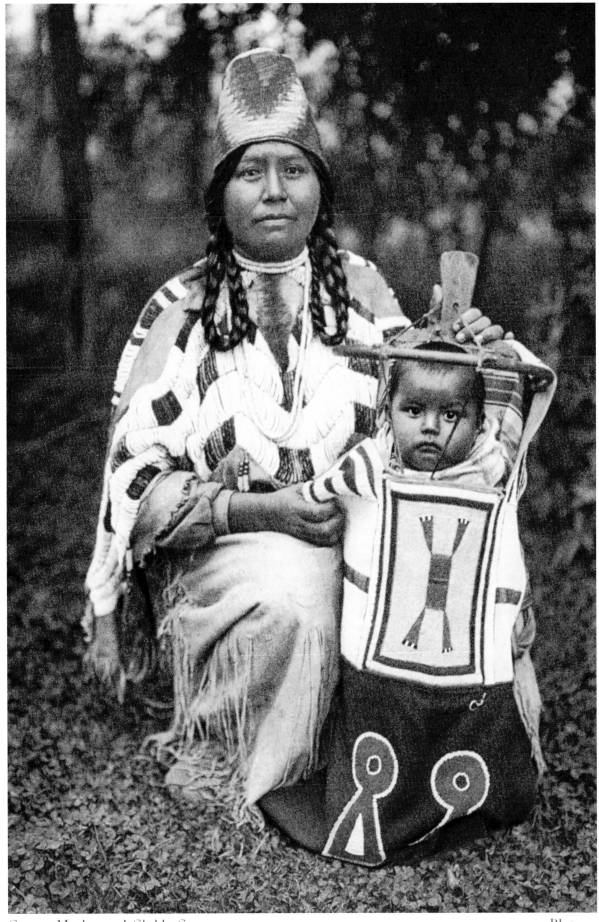

Cayuse Mother and Child—Cayuse, 1911 Plate 19

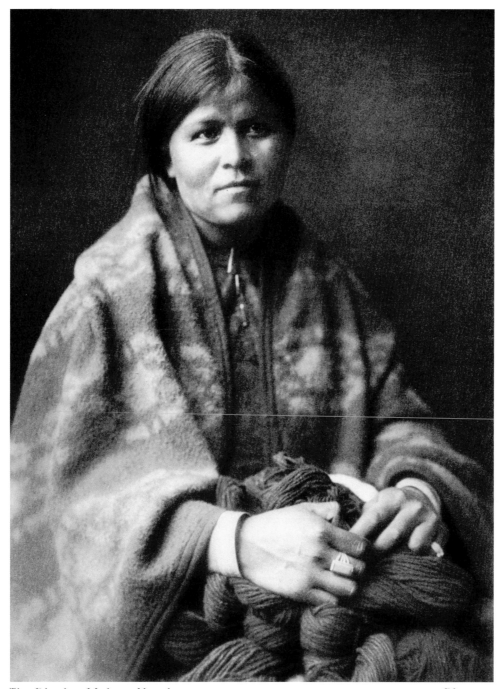

The Blanket Maker—Navaho, 1907 Plate 20

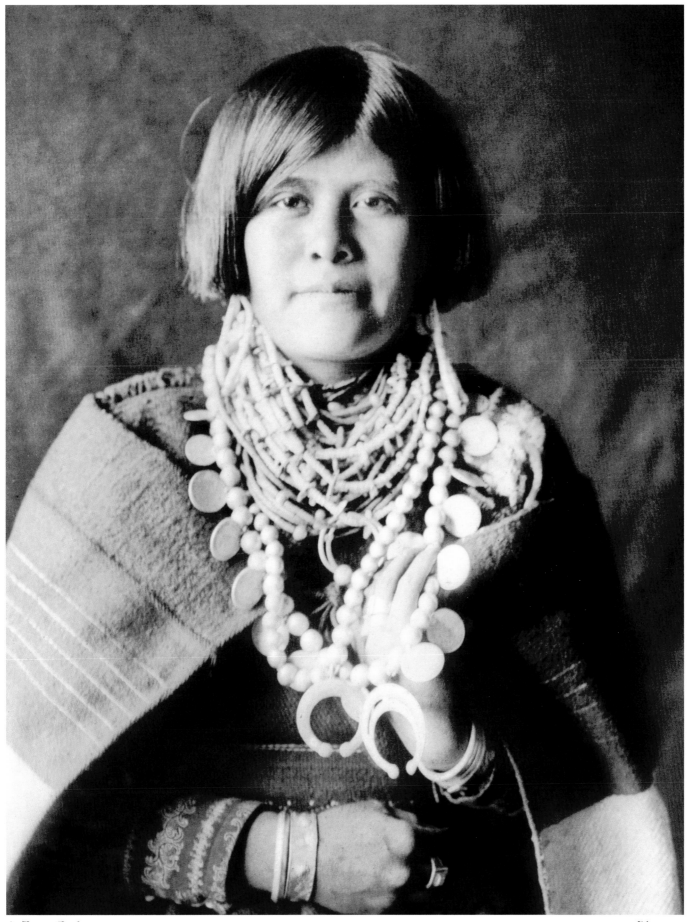

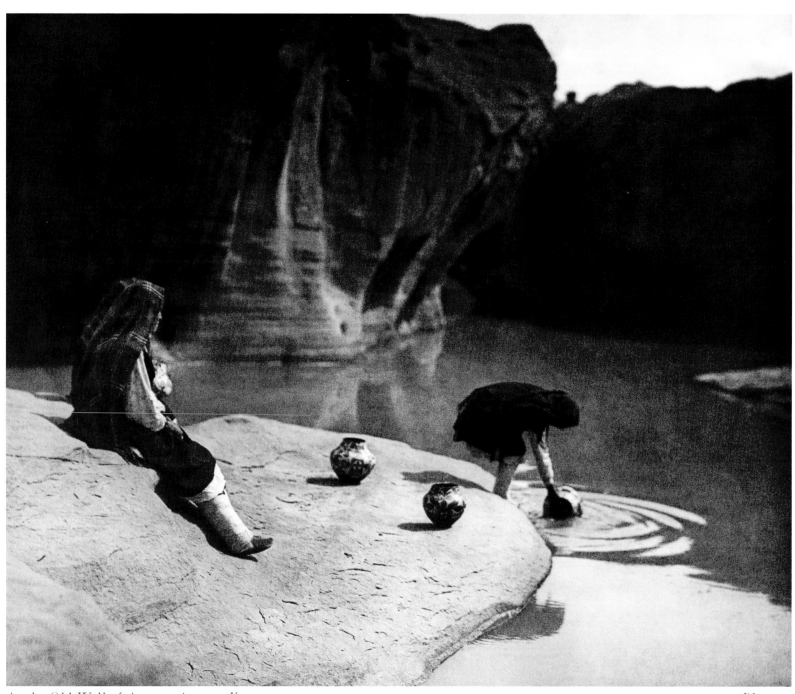

At the Old Well of Acoma—Acoma—Keres, 1904 Plate 22

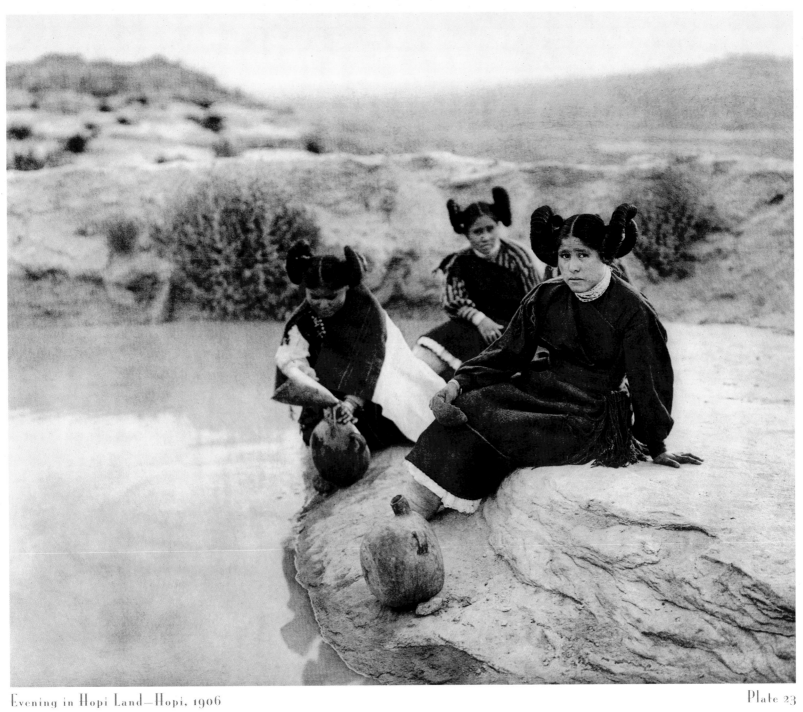

Evening in Hopi Land—Hopi, 1906

Plate 23

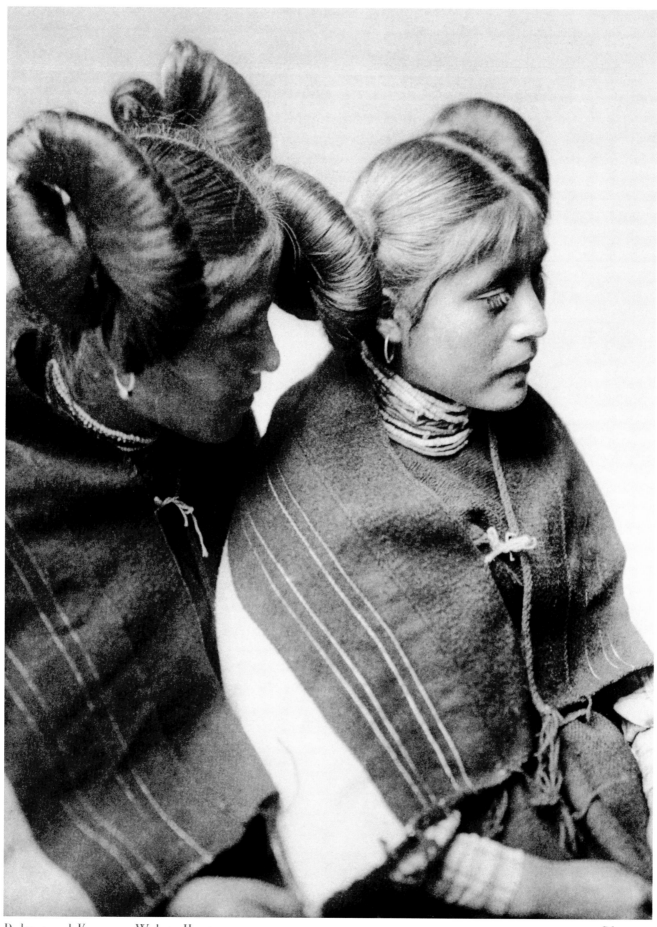

Puliini and Koyame—Walpi—Hopi, 1922

Plate 24

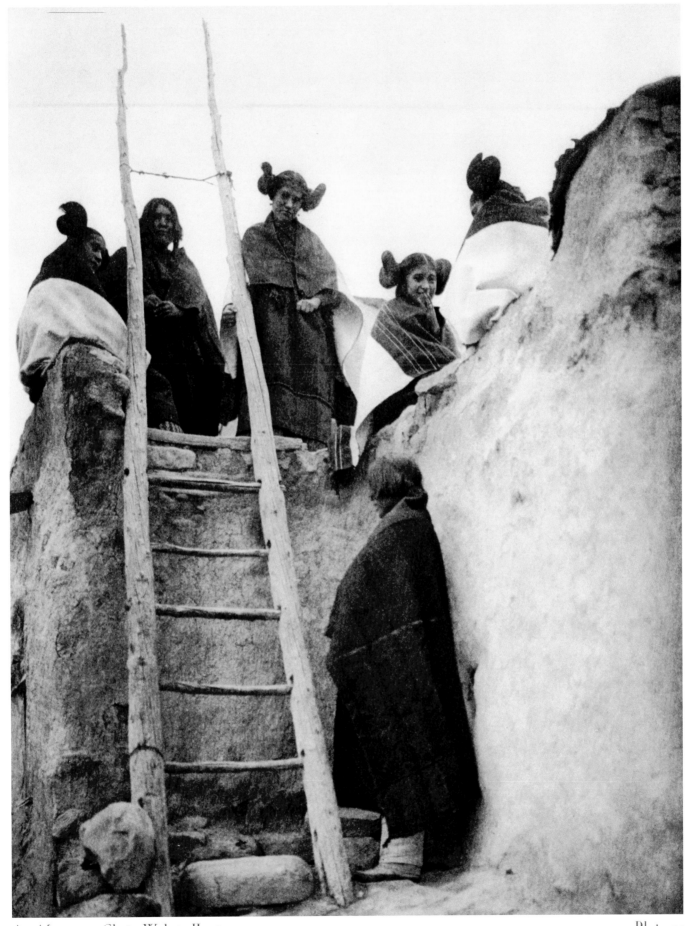

An Afternoon Chat—Walpi—Hopi, 1922 Plate 25

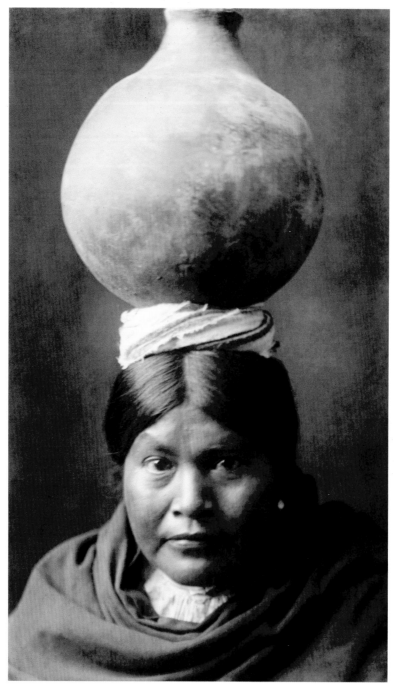

Untitled Mohave Woman, 1904 Plate 26

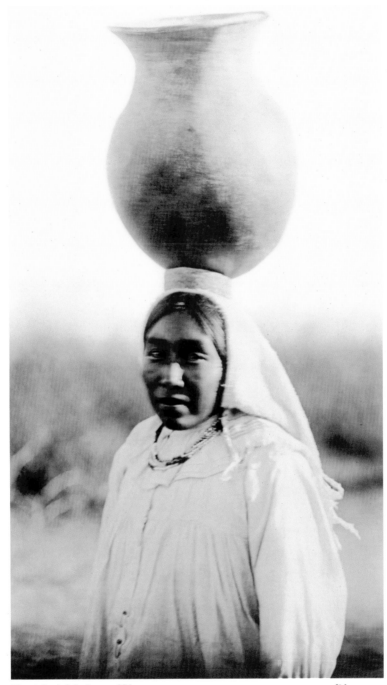

Untitled Mohave Woman, 1904 Plate 27

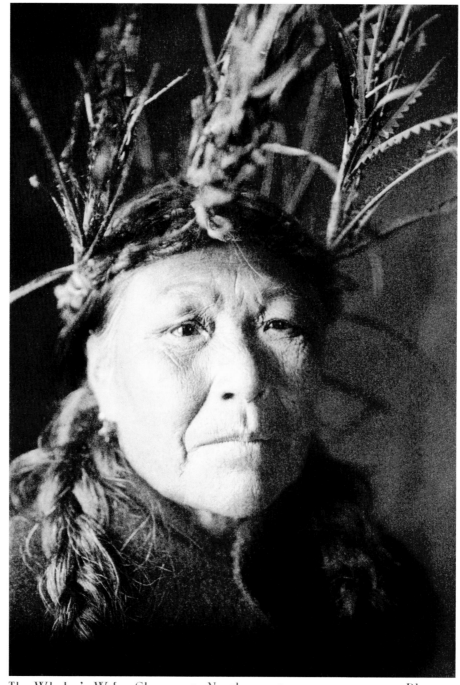

The Whaler's Wife—Clayoquot—Nootka, 1916 Plate 28

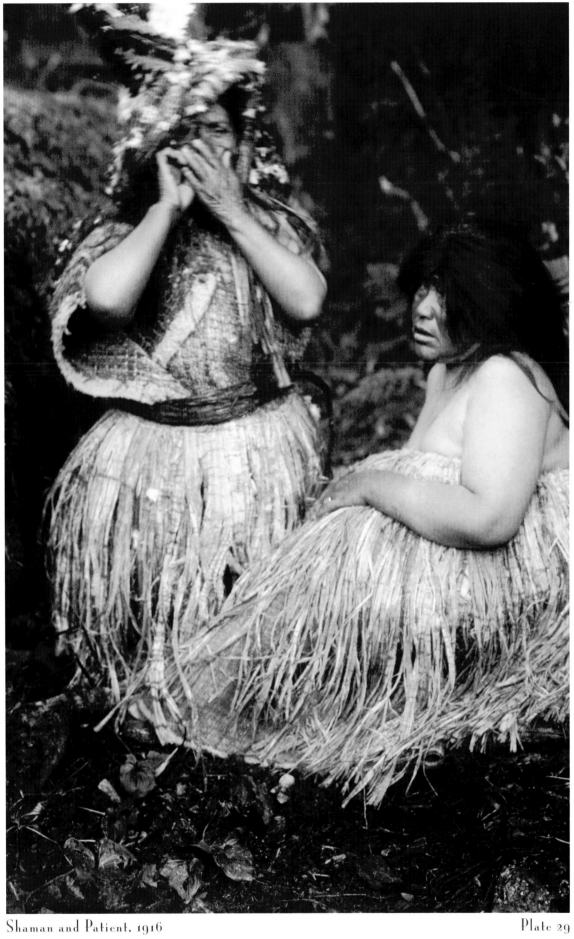

Shaman and Patient, 1916 Plate 29

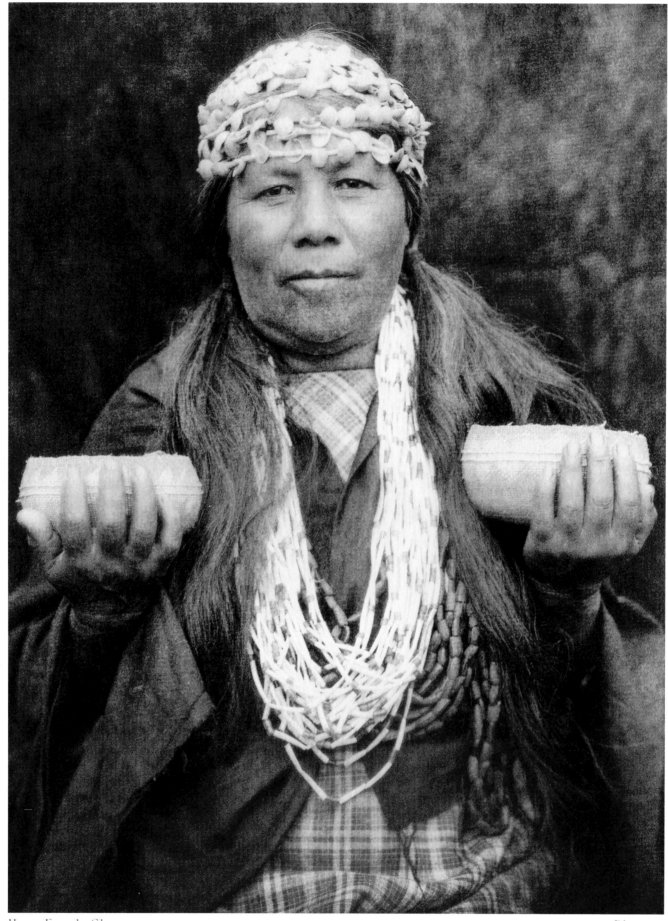

Hupa Female Shaman, 1924 Plate 30

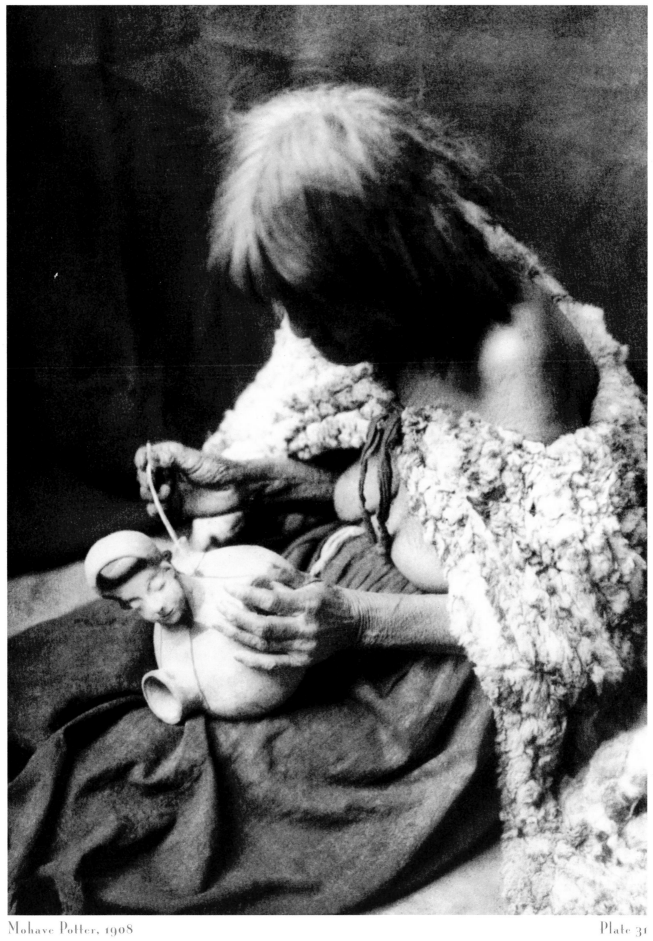

Mohave Potter, 1908 Plate 31

The soil you see is not ordinary soil—it is the dust of the blood, the flesh, and the bones of our ancestors.... You will have to dig down through the surface before you can find nature's earth... as the upper portion is Crow. The land, as it is, is my blood and my dead; it is consecrated, and I do not want to give up any portion of it.

—Curley (Crow), 1936

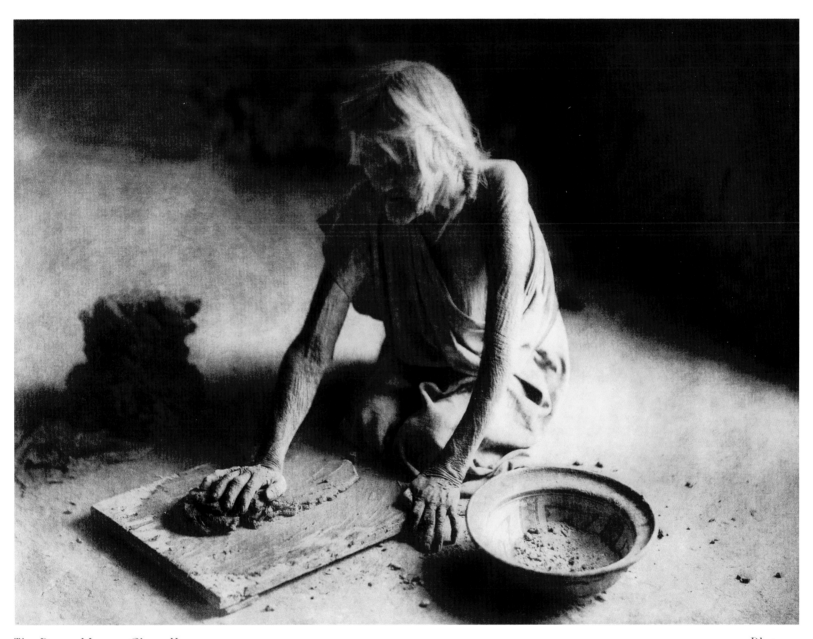

The Potter Mixing Clay—Hopi, 1921 Plate 32

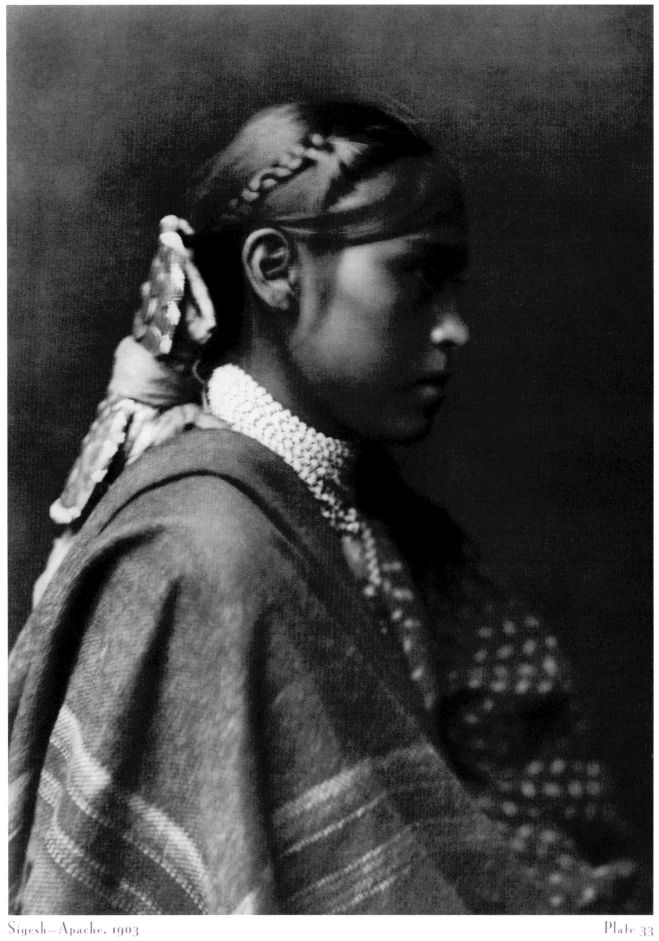

Sigesh—Apache, 1903 Plate 33

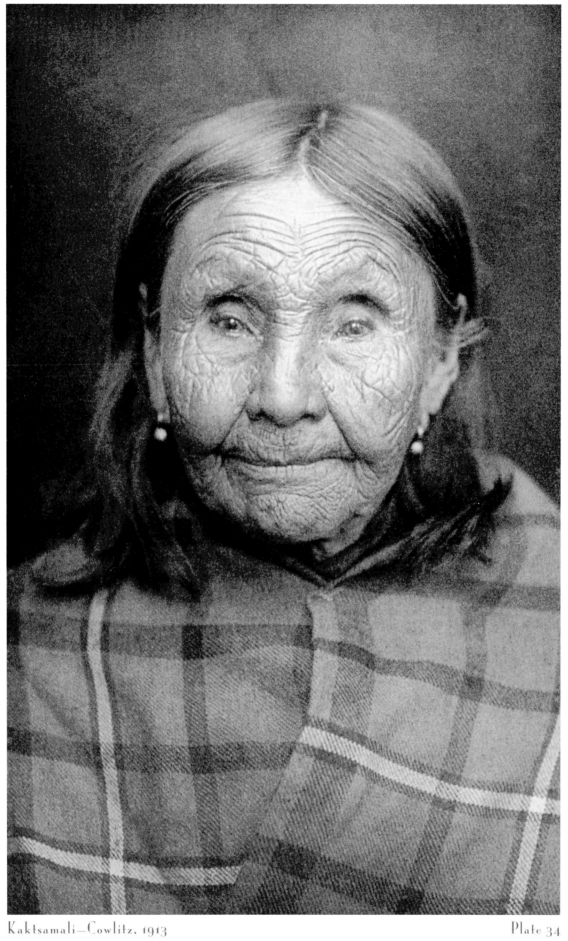

Kaktsamali—Cowlitz, 1913 Plate 34

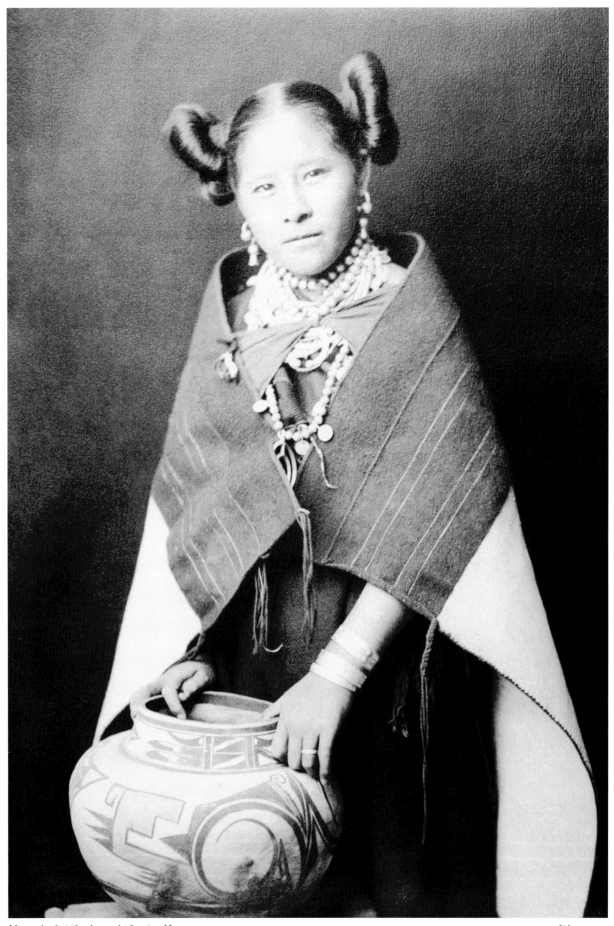

Untitled (Girl with Jar)—Hopi, 1900 Plate 35

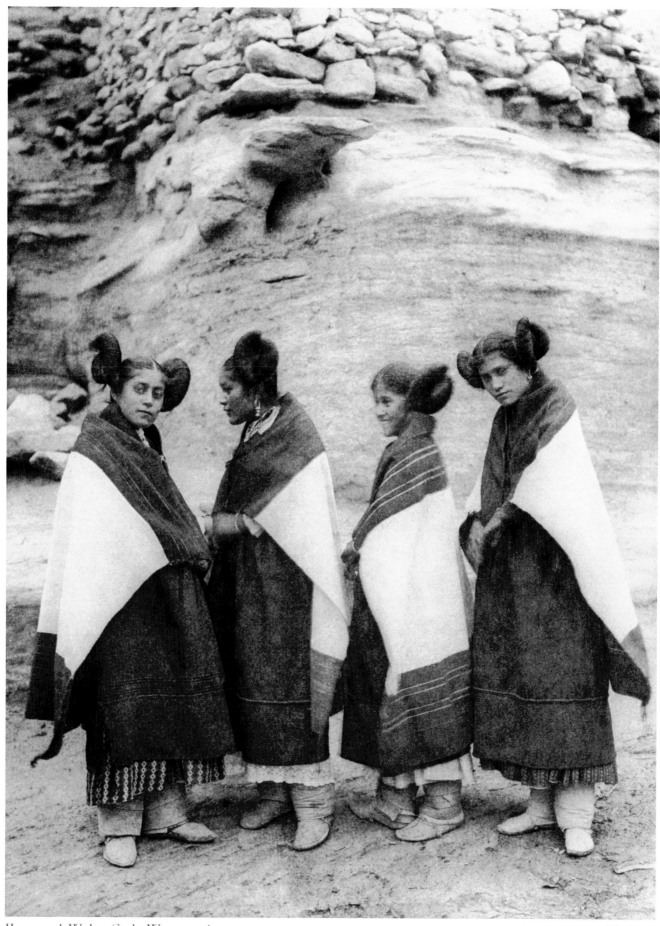

Hano and Walpi Girls Wearing Atoo, 1922 Plate 36

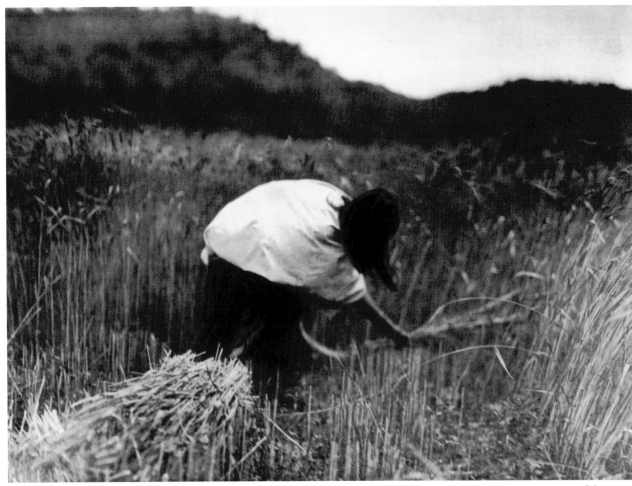

The Apache Reaper, 1906 Plate 37

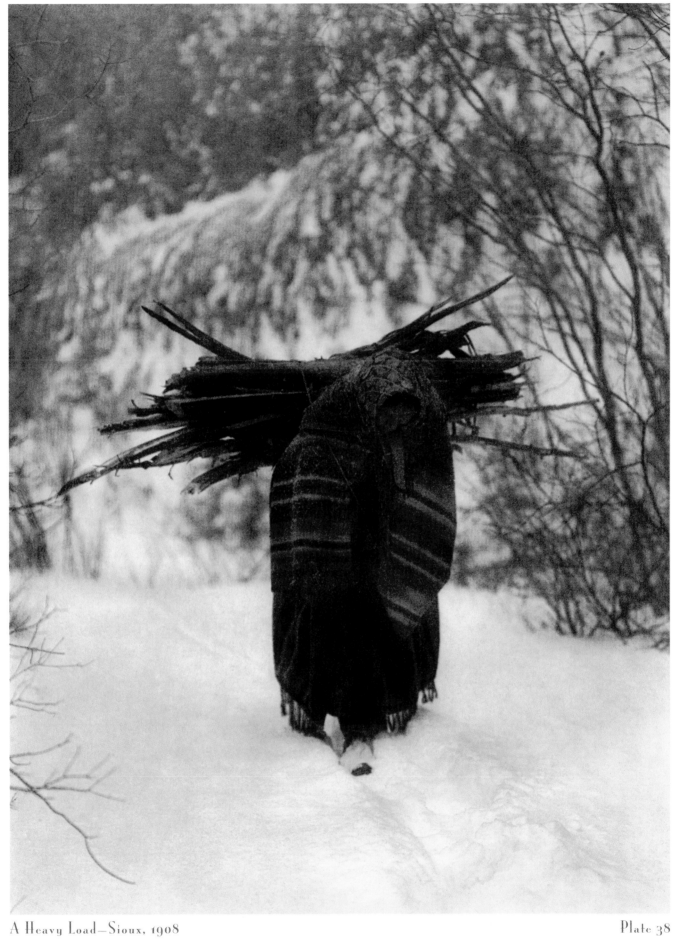

A Heavy Load—Sioux, 1908 Plate 38

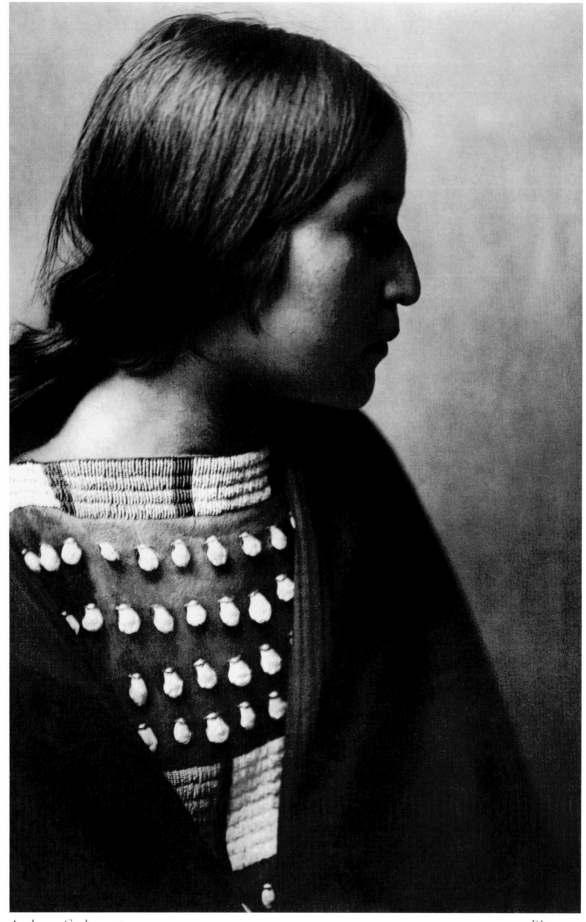

Arikara Girl, 1908 Plate 39

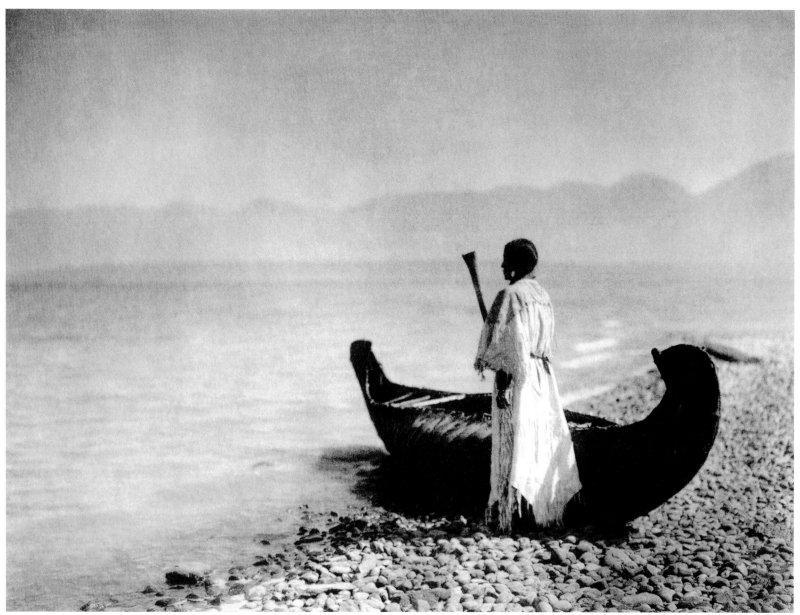

Kutenai Woman, 1910 Plate 40

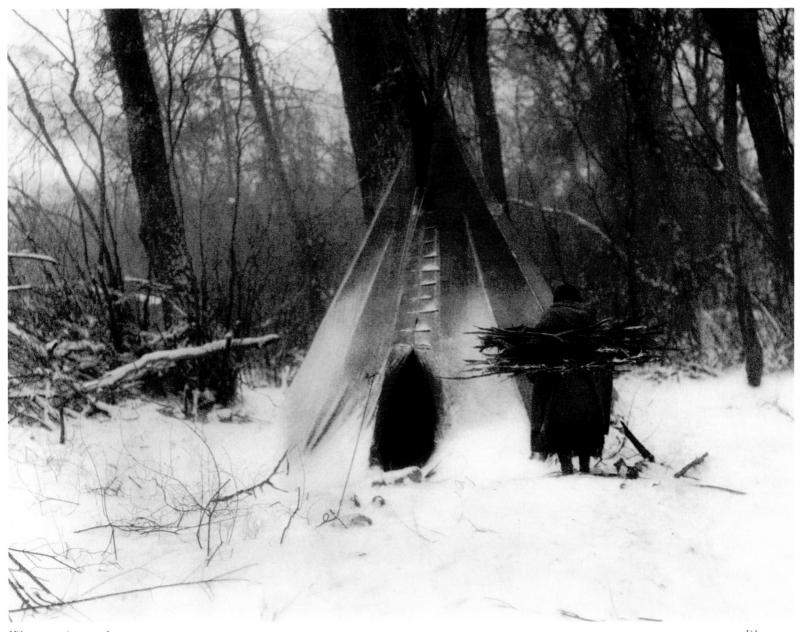

Winter—Apsaroke, 1908 Plate 41

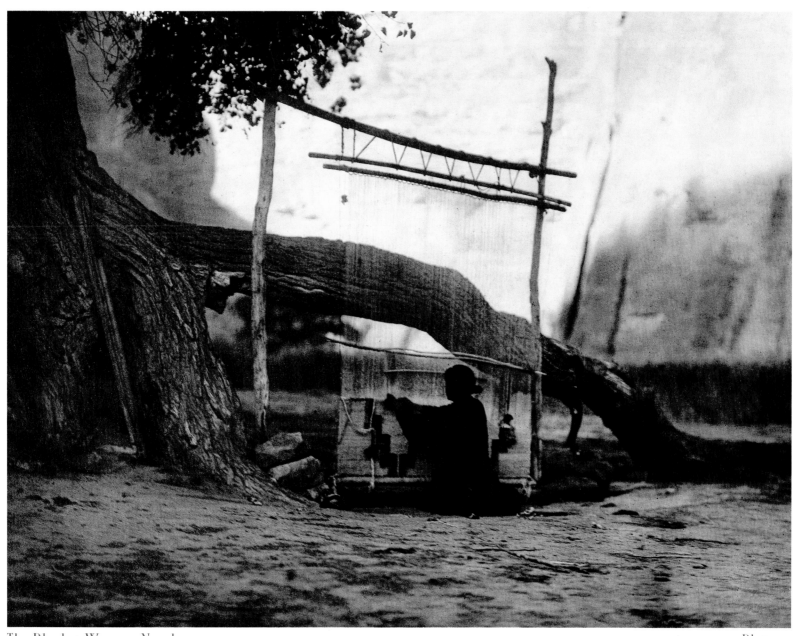

The Blanket Weaver—Navaho, 1904

Plate 42

Everything that gives birth is female. When men begin to understand the relationships of the universe that women have always known, the world will begin to change for the better.

–Lorraine Canoe (Mohawk), 1993

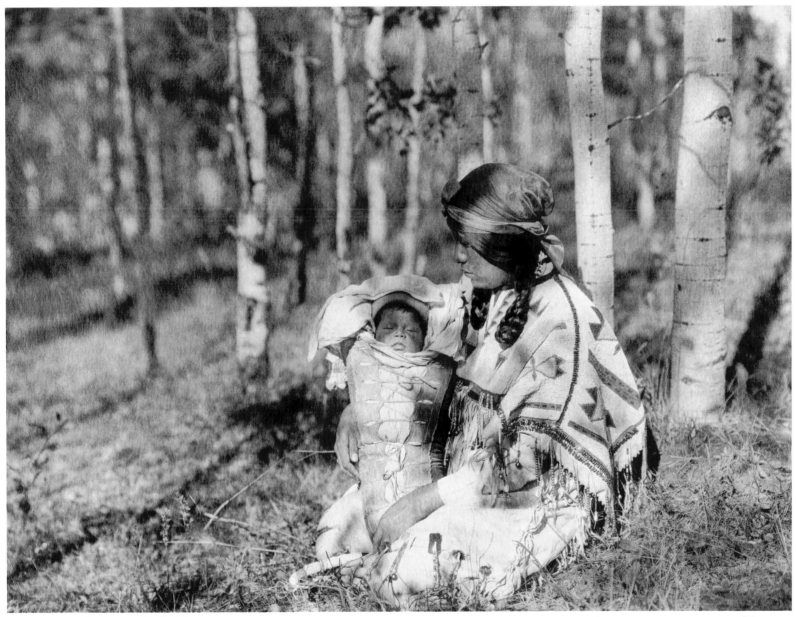

Assiniboin Mother and Child, 1926

Plate 43

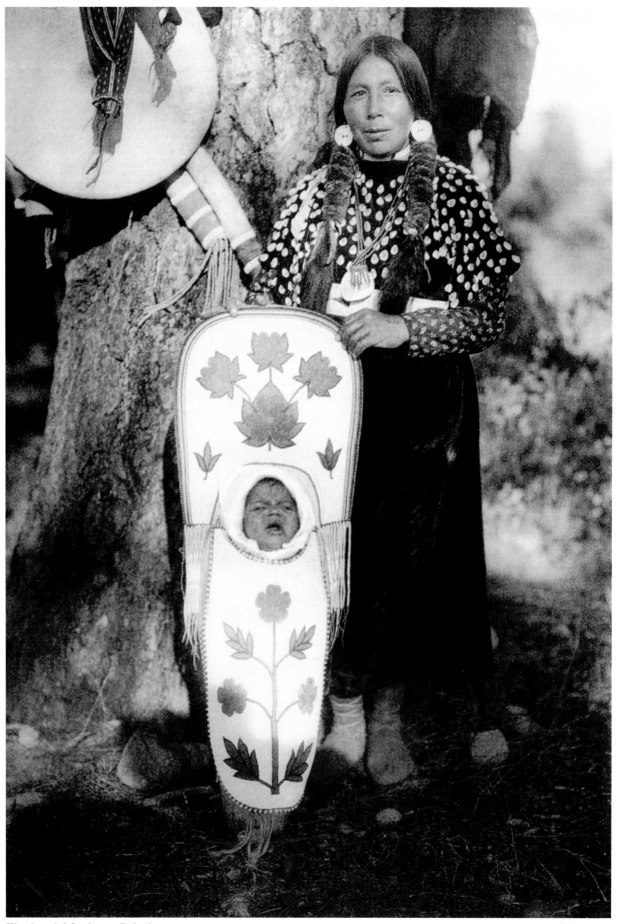

Flathead Mother—Salishan, 1911

Plate 44

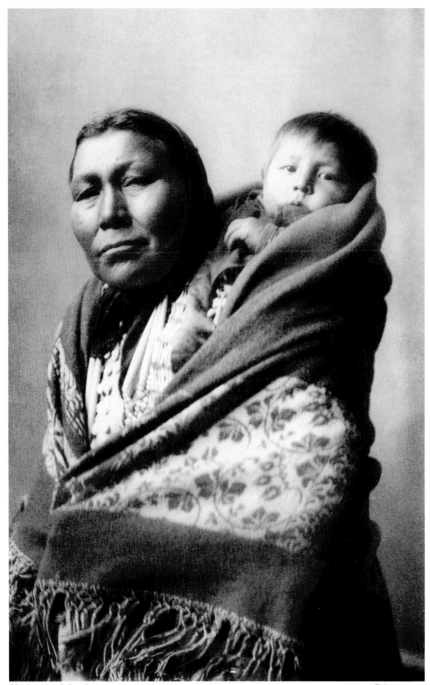

Hidatsa Mother, 1909 Plate 45

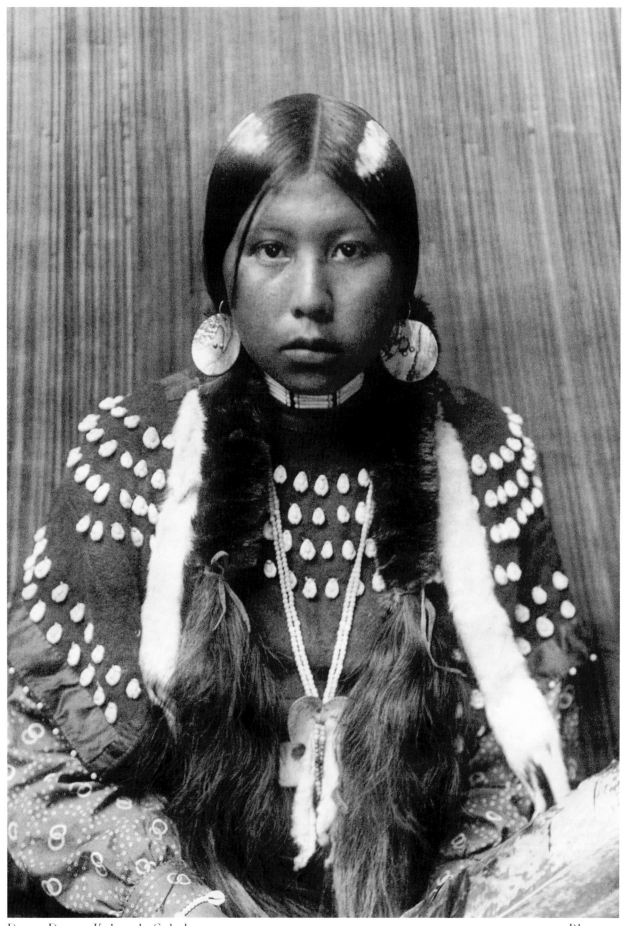

Dusty Dress—Kalispel—Salishan, 1910

Plate 46

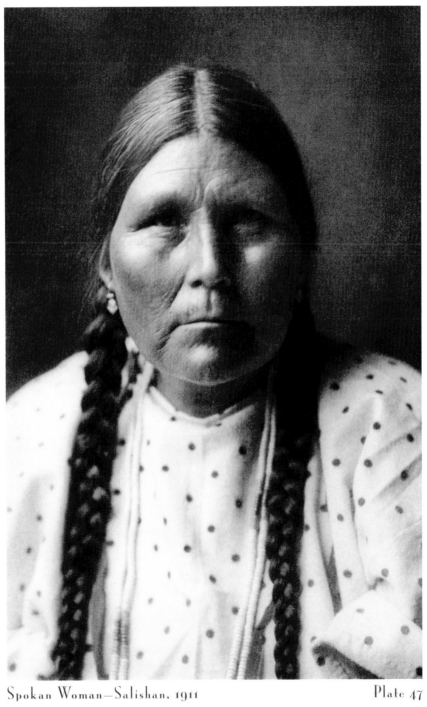

Spokan Woman—Salishan, 1911 Plate 47

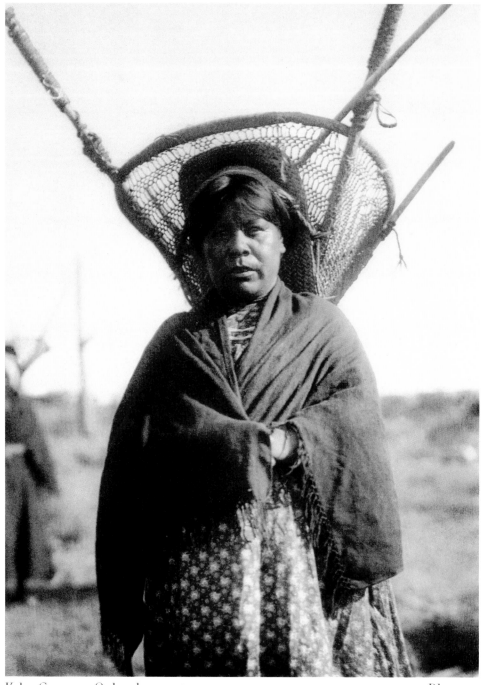

Kiho Carrier—Qahatika, 1908 Plate 48

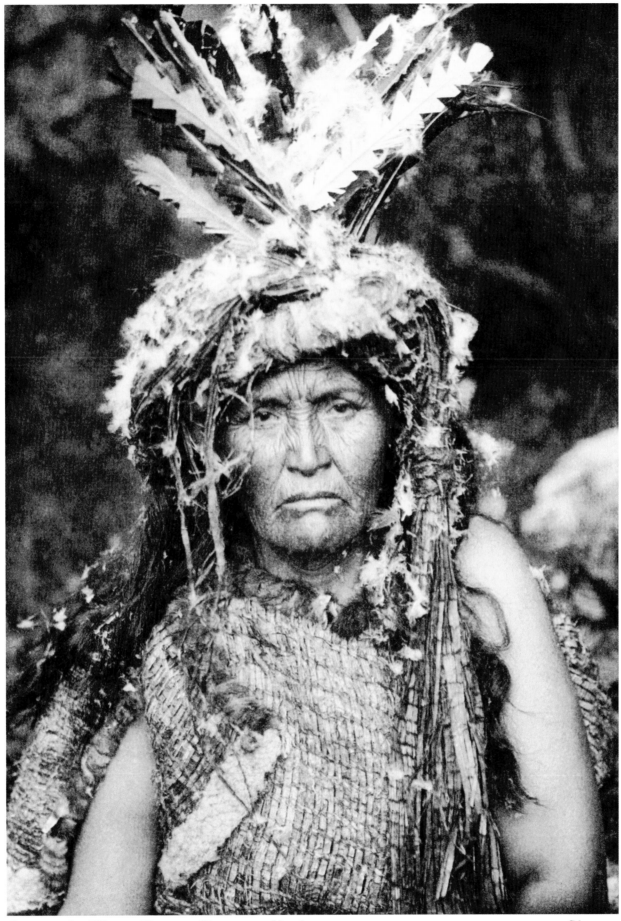

Costume of a Woman Shaman—Clayoquot—Nootka, 1916 Plate 49

The Great Spirit is our father, but the Earth is our mother. She nourishes us; that which we put into the ground she returns to us, and healing plants she gives us likewise. If we are wounded, we go to our mother and seek to lay the wounded part against her, to be healed.

—Big Thunder (Wabanaki Algonquin), late 19th century

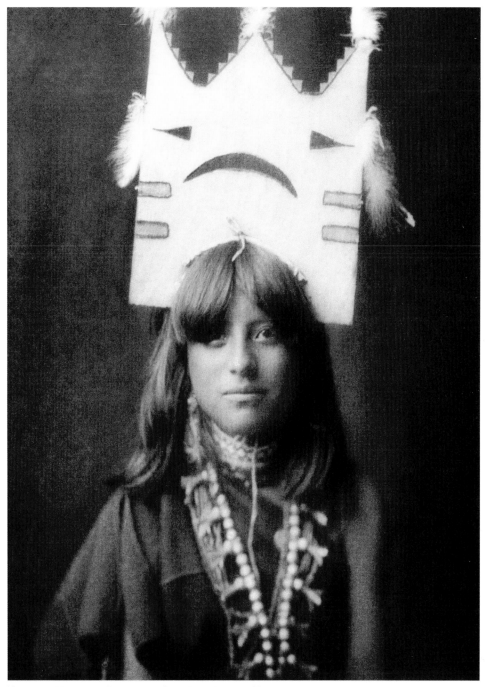

Tablita Woman Dancer—San Ildefonso—Tewa, 1926 Plate 50

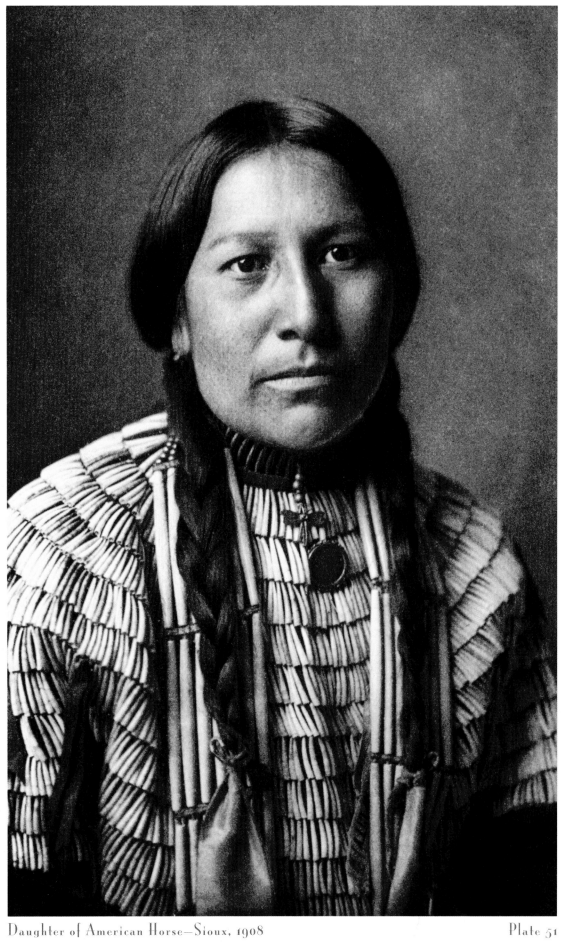

Daughter of American Horse—Sioux, 1908 Plate 51

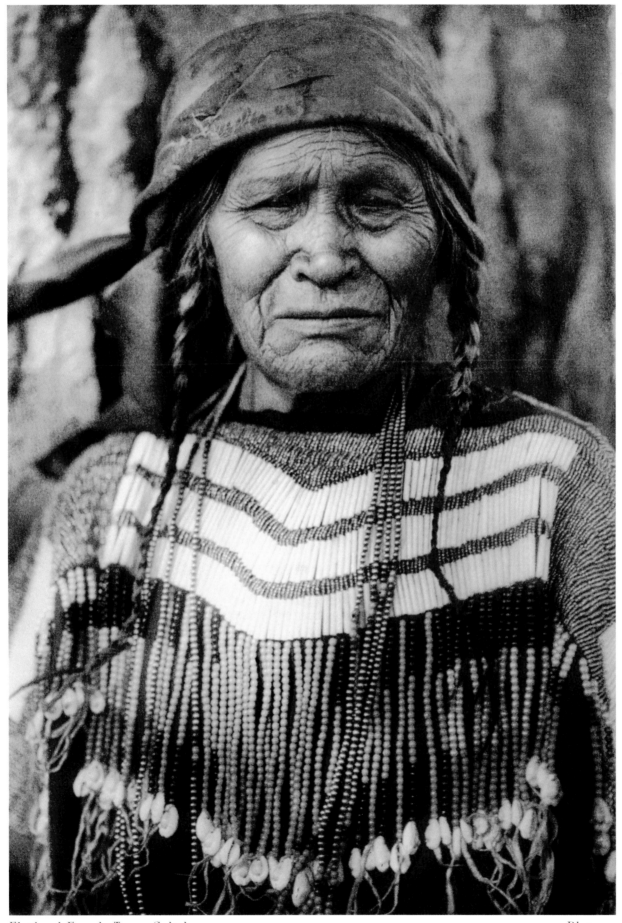

Flathead Female Type—Salishan, 1911

Plate 52

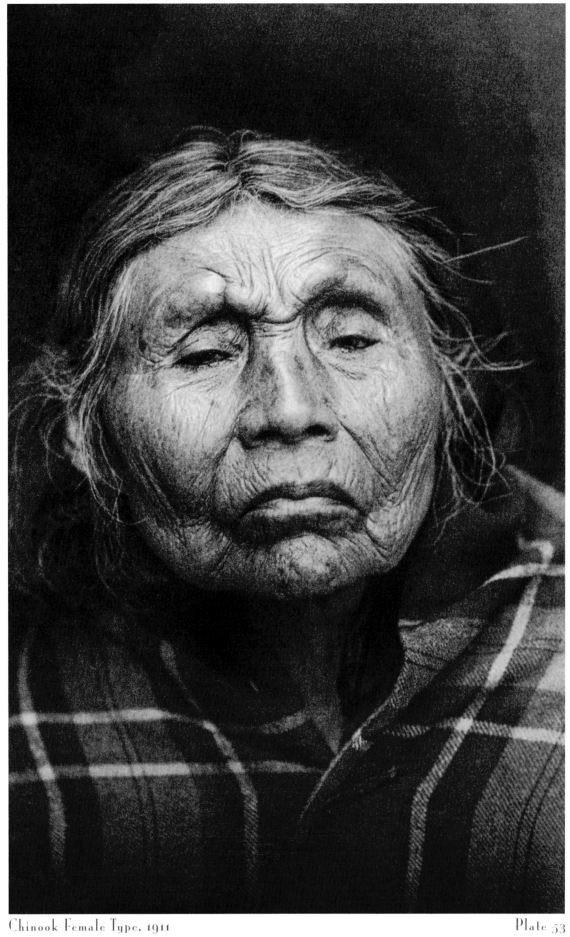

Chinook Female Type, 1911

Plate 53

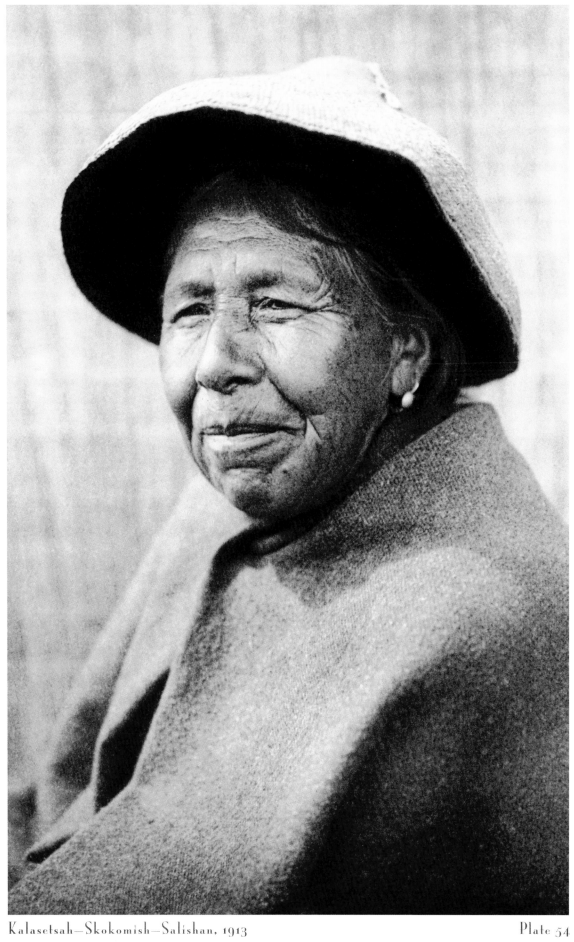

Kalasetsah—Skokomish—Salishan, 1913 Plate 54

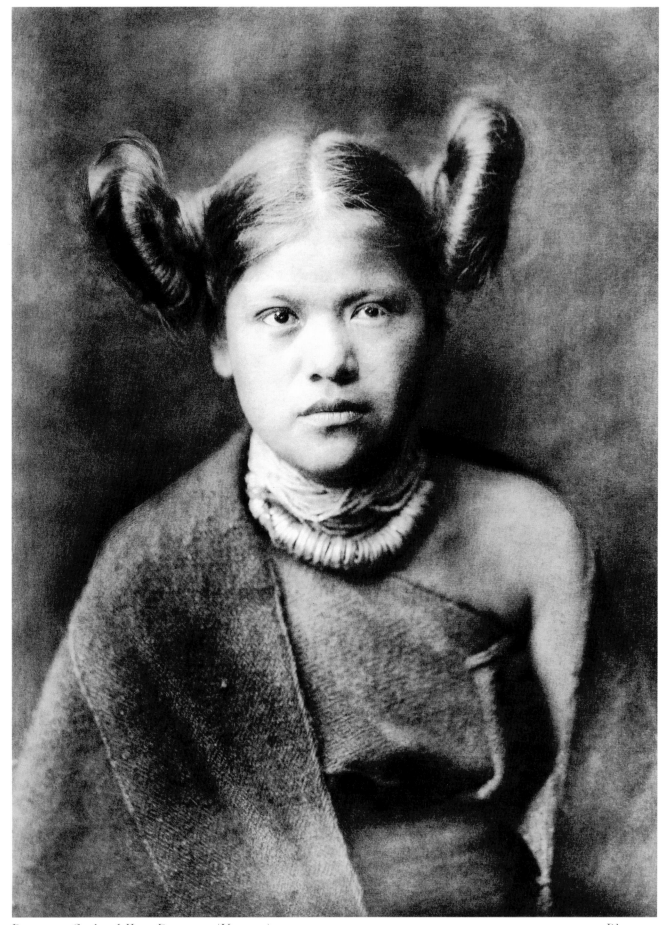

Primitive Style of Hair Dressing (Variant), 1921 Plate 55

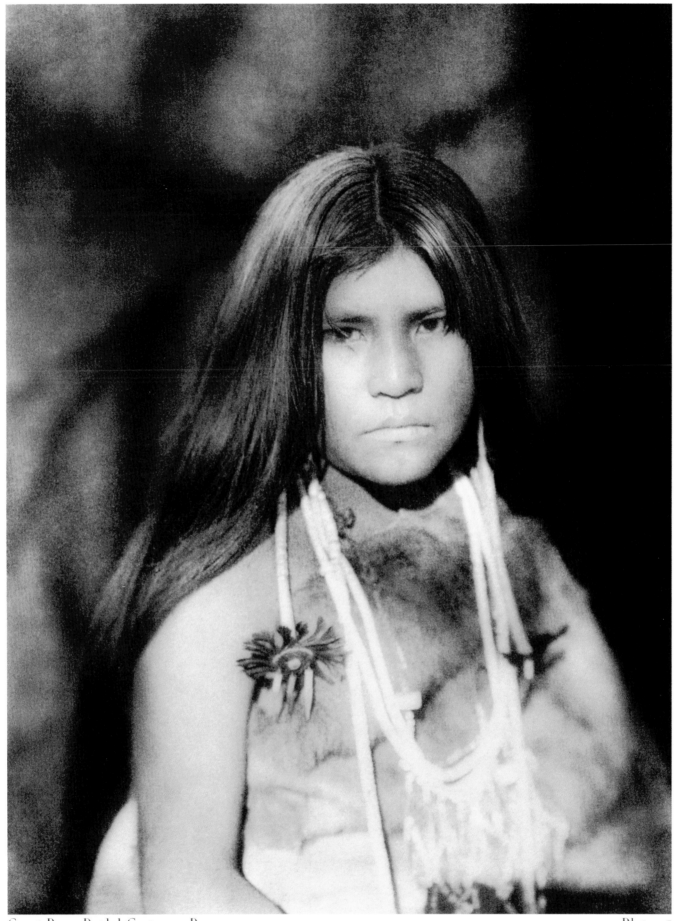

Coast Pomo Bridal Costume—Pomo, 1924

Plate 56

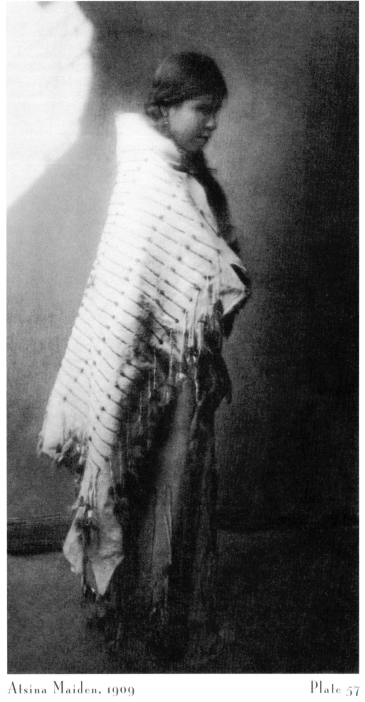

Atsina Maiden, 1909 Plate 57

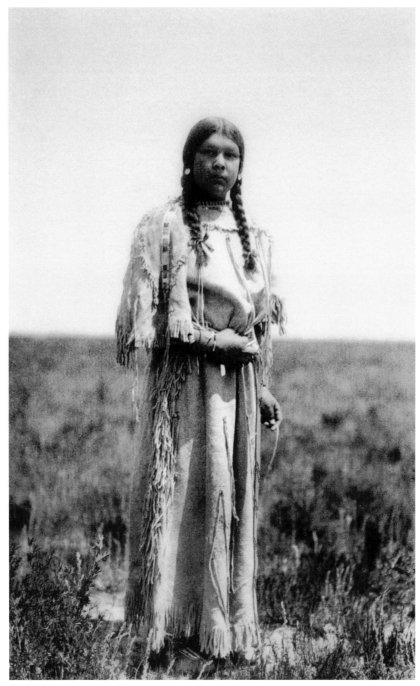

The Chief Had A Beautiful Daughter—Apsaroke, 1909 Plate 58

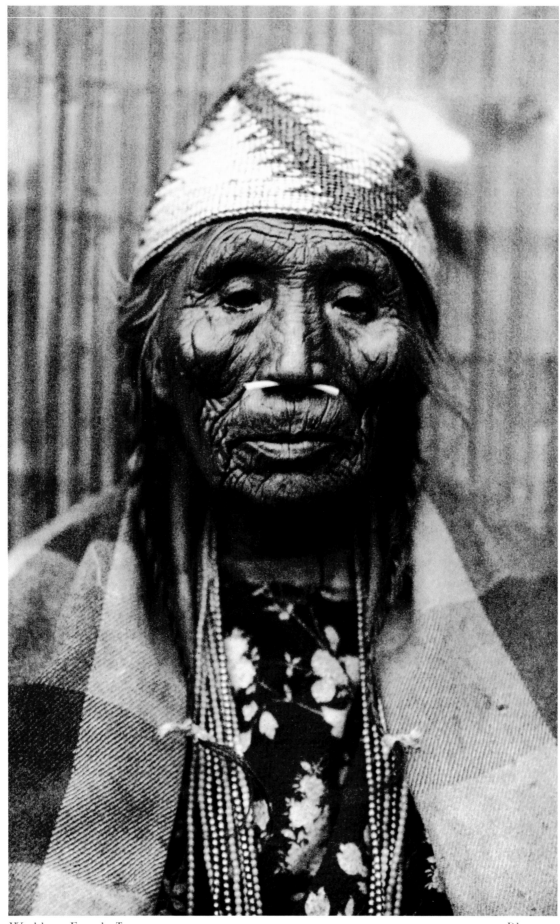

Wishham Female Type, 1911 Plate 59

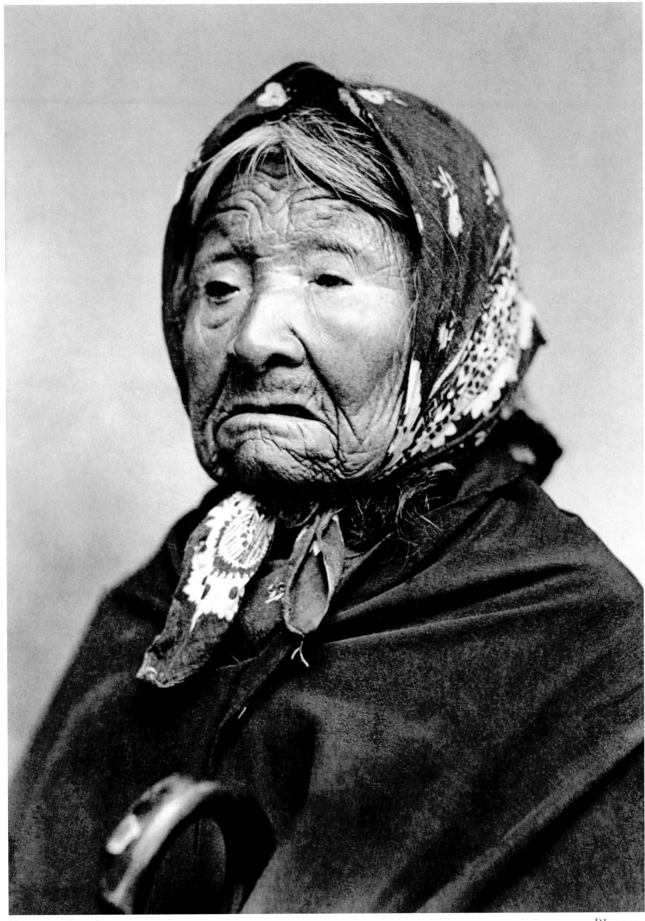

Princess Angeline, 1899

Plate 60

The Great Spirit has made us what we are; it is not his will that we should be changed. If it was his will, he would let us know; if it is not his will, it would be wrong for us to attempt it, nor could we, by any art, change our nature.

—Seneca Proverb

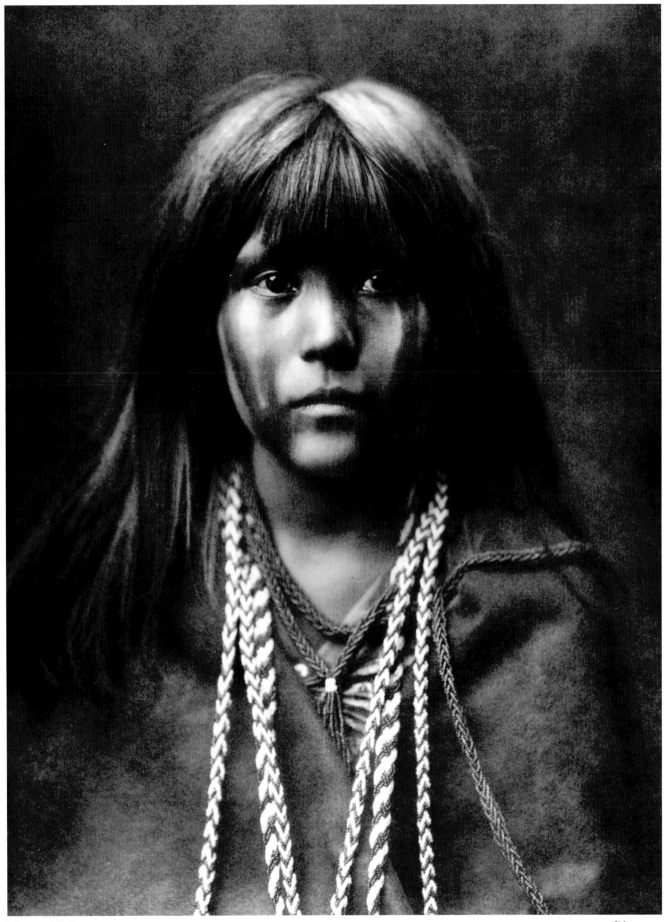

Mosa—Mohave, 1903

Plate 61

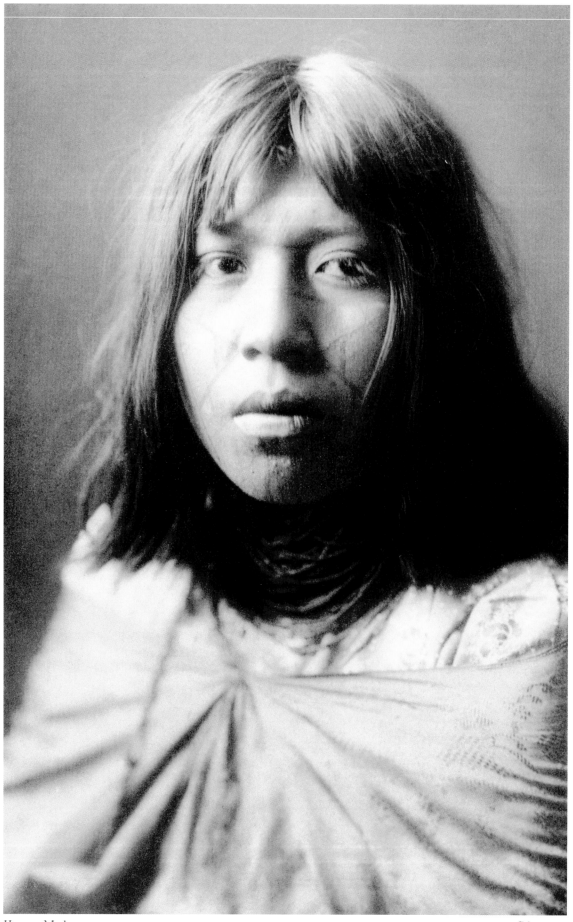

Hipa—Mohave, 1909 Plate 62

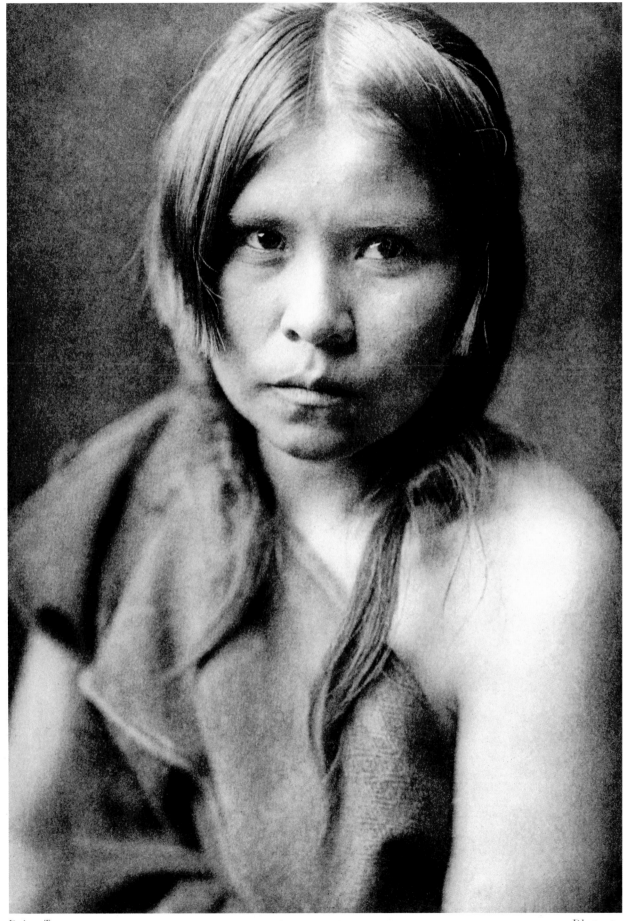

Pele–Tewa, 1922 Plate 63

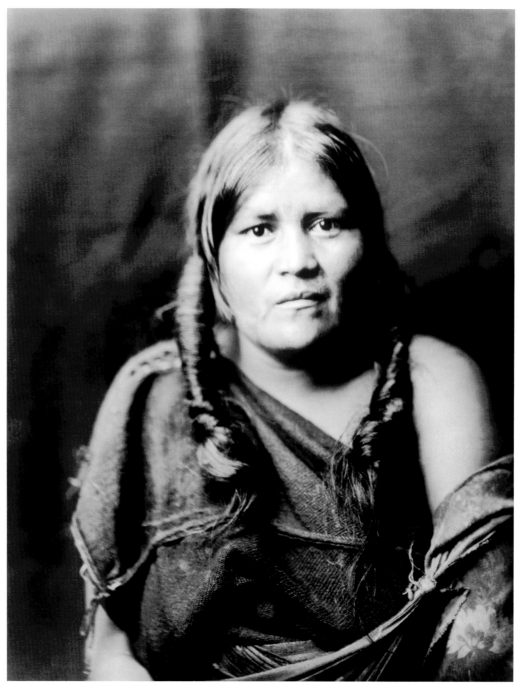

A Hopi Woman (Unpublished Variant) Plate 64

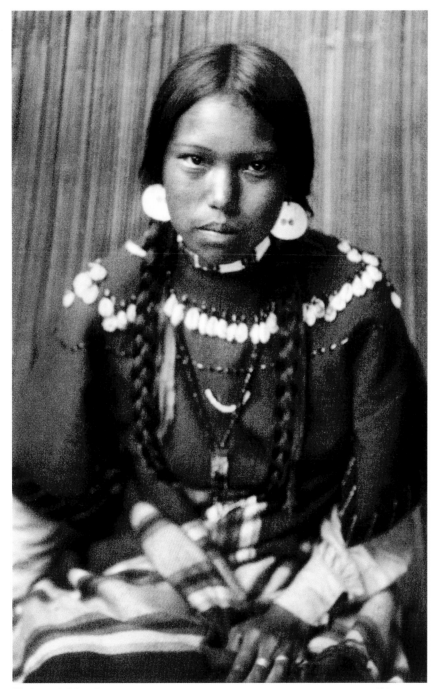

Kalispel Maiden, 1911 Plate 65

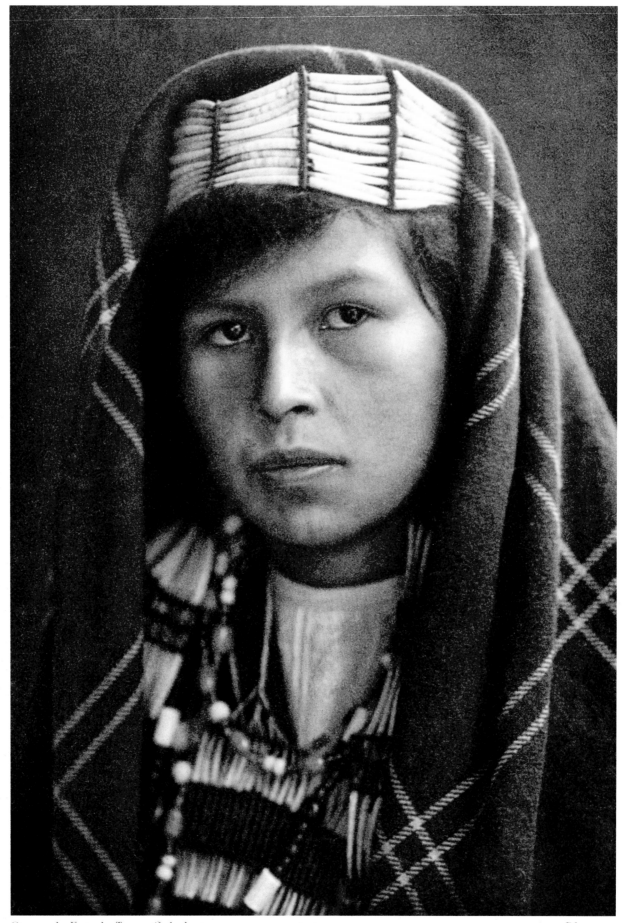

Quinault Female Type—Salishan, 1913

Plate 66

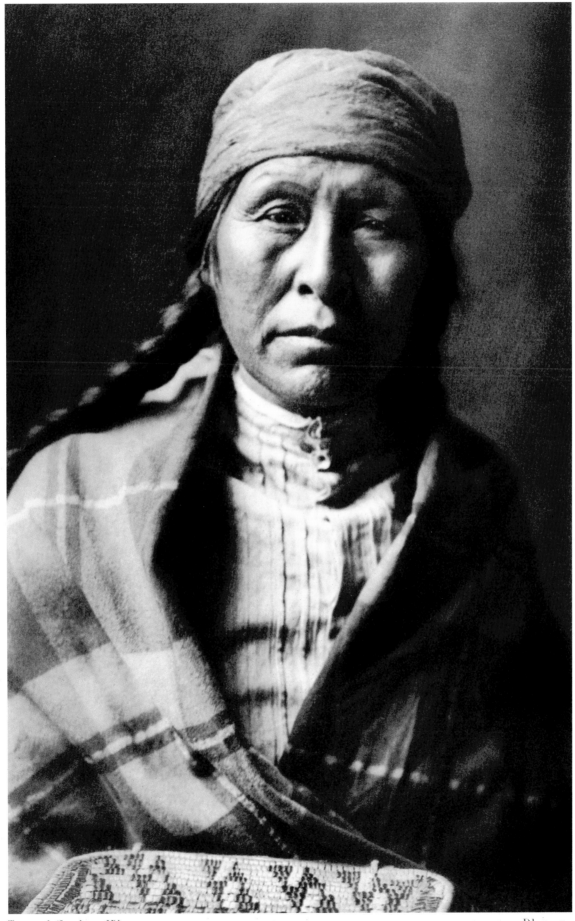

Typical Spokan Woman, 1911 Plate 67

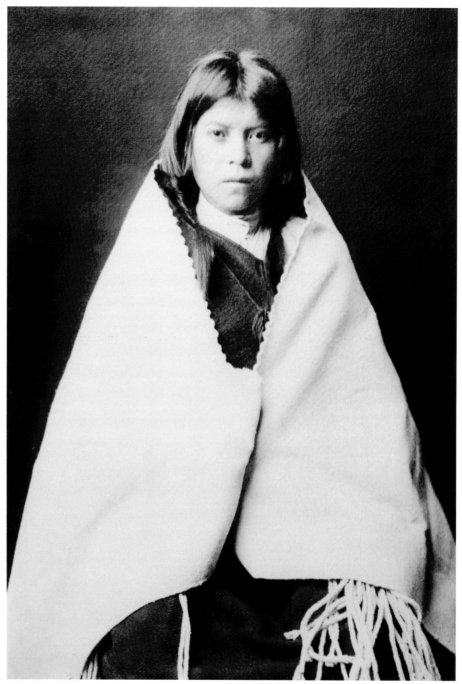

Hopi Bridal Costume (Variant) Plate 68

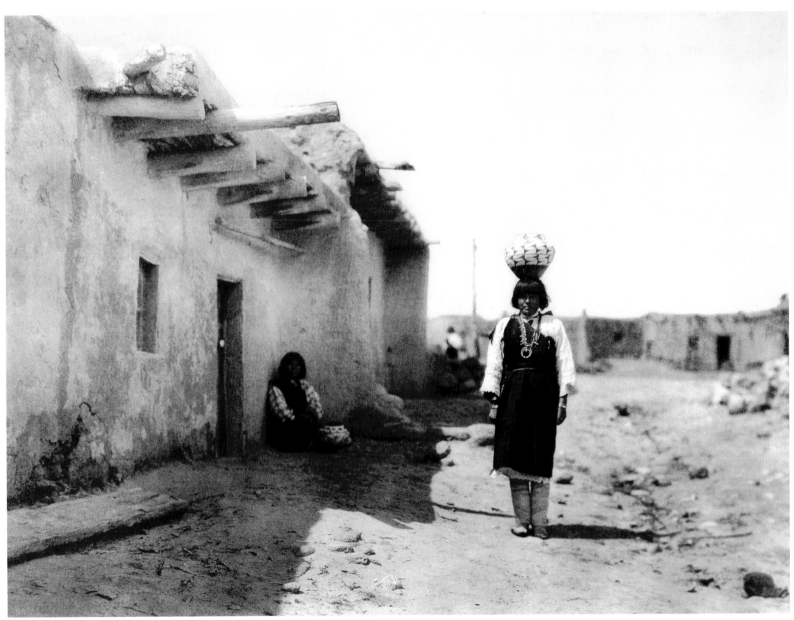

Sia Street Scene—Keres, 1925

Plate 69

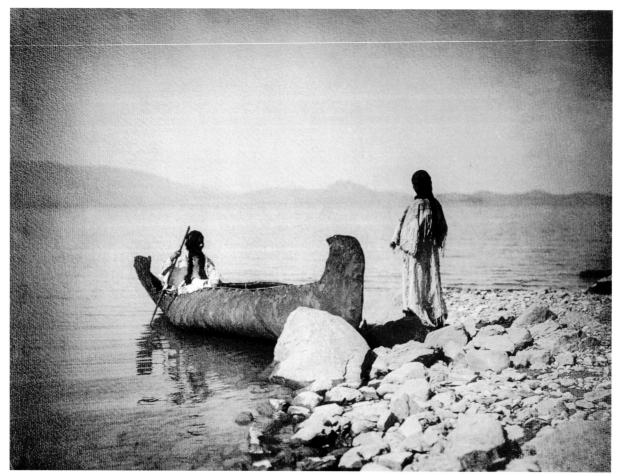

Embarking—Kutenai, 1910 Plate 70

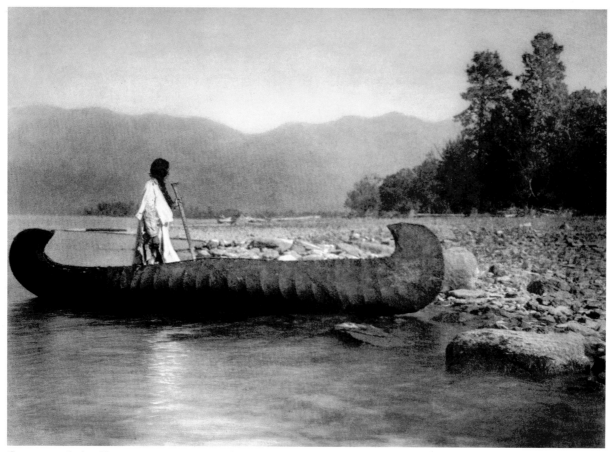

Country of the Kutenai, 1910 Plate 71

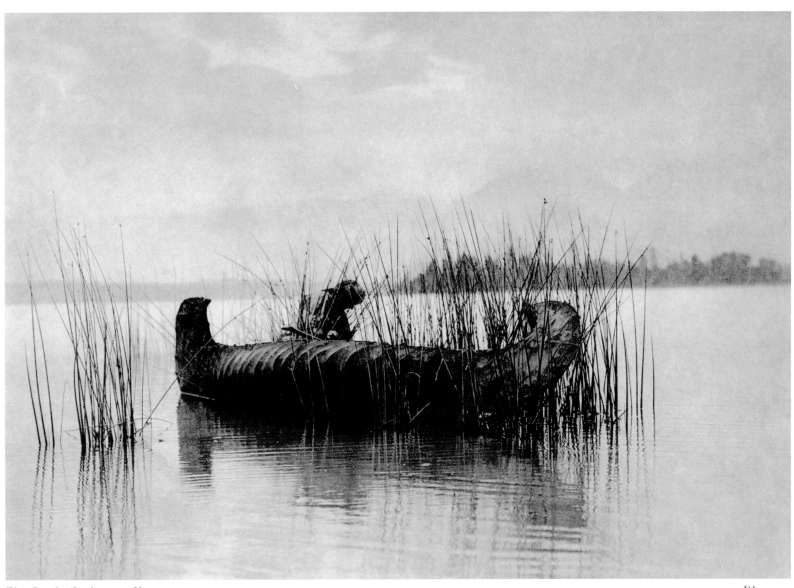

The Rush Gatherer—Kutenai, 1910 Plate 72

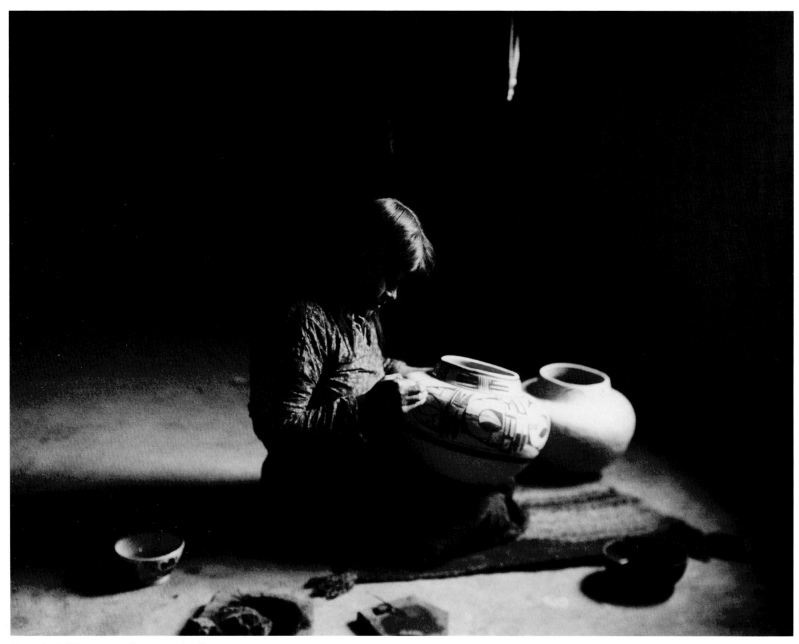

Untitled (Nampéyo Painting)—Hopi, 1900

Plate 73

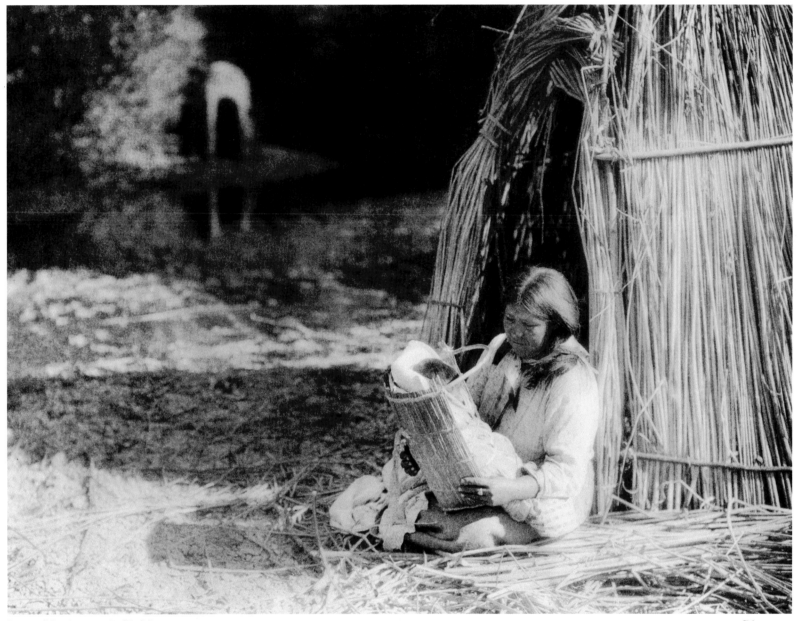

Pomo Mother and Child, 1924 Plate 74

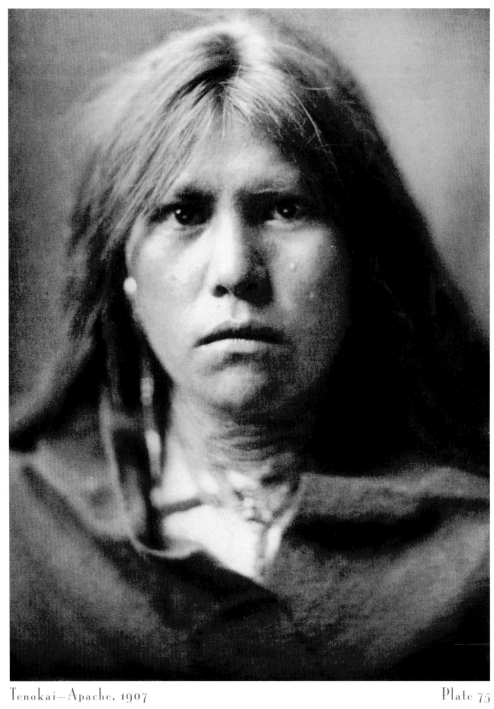

Tenokai—Apache, 1907 Plate 75

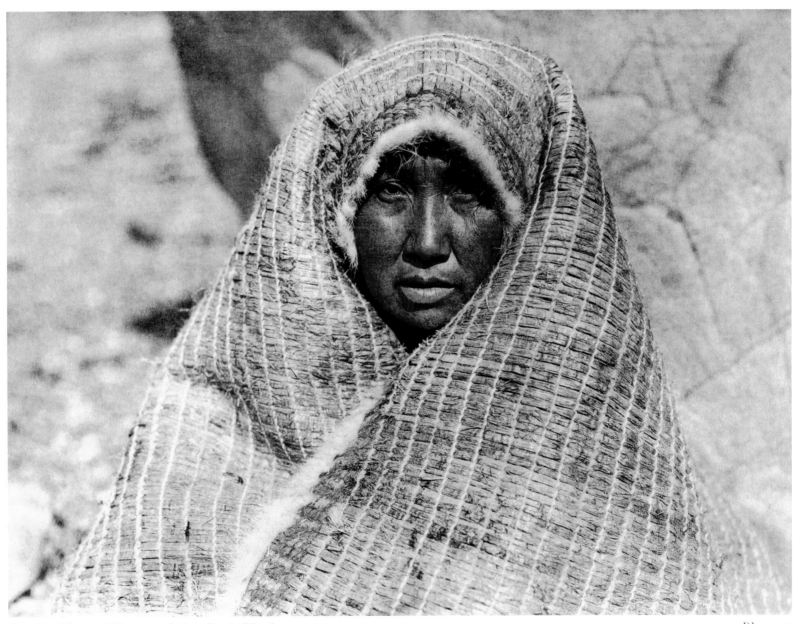

Nootka Woman Wearing Cedar-Bark Blanket, 1915

Plate 76

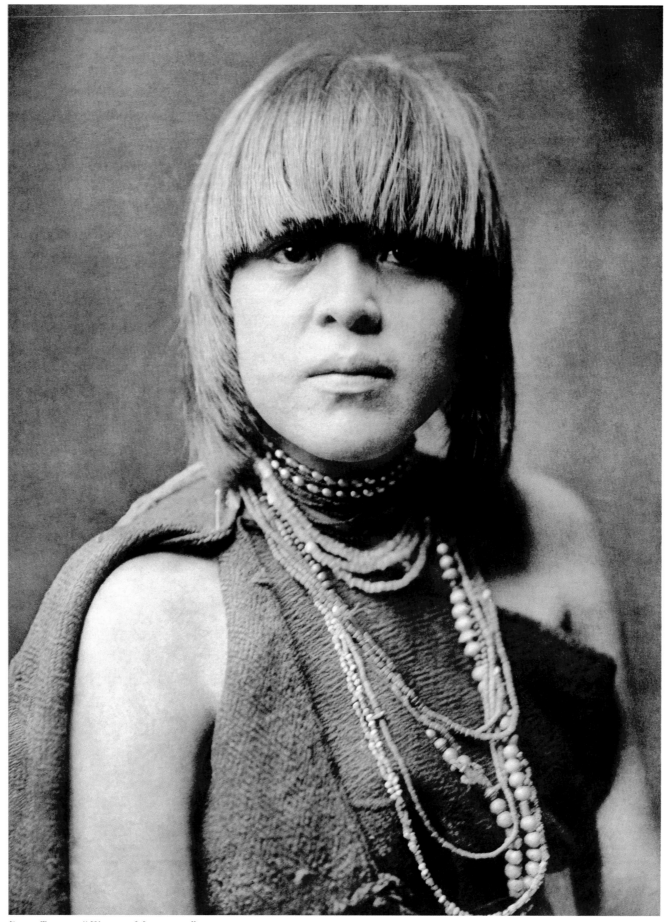

Pôvi-Támu—"Flower Morning," 1905 Plate 77

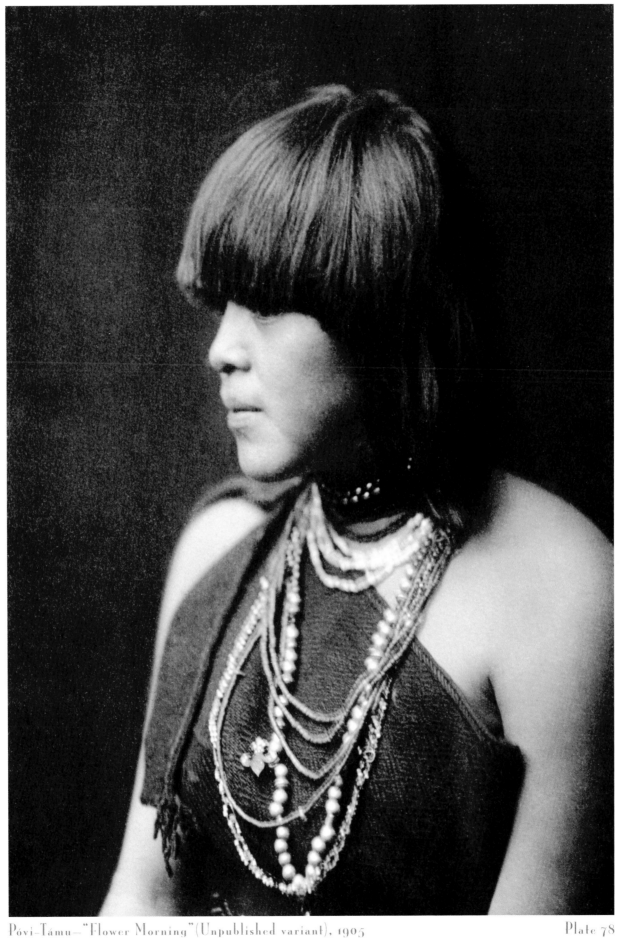

Póvi-Támu—"Flower Morning" (Unpublished variant), 1905 Plate 78

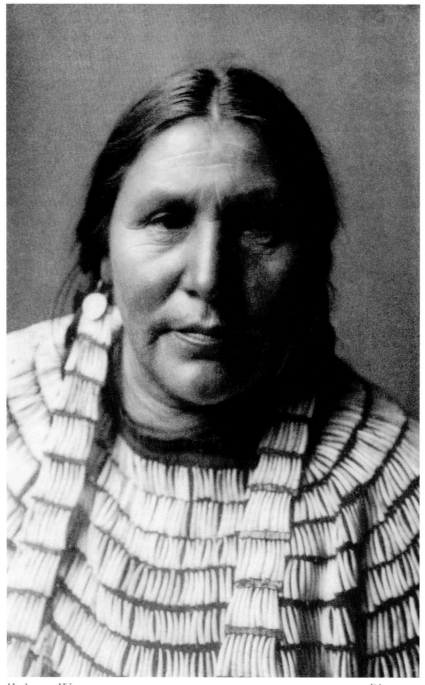

Hidatsa Woman, 1909 Plate 79

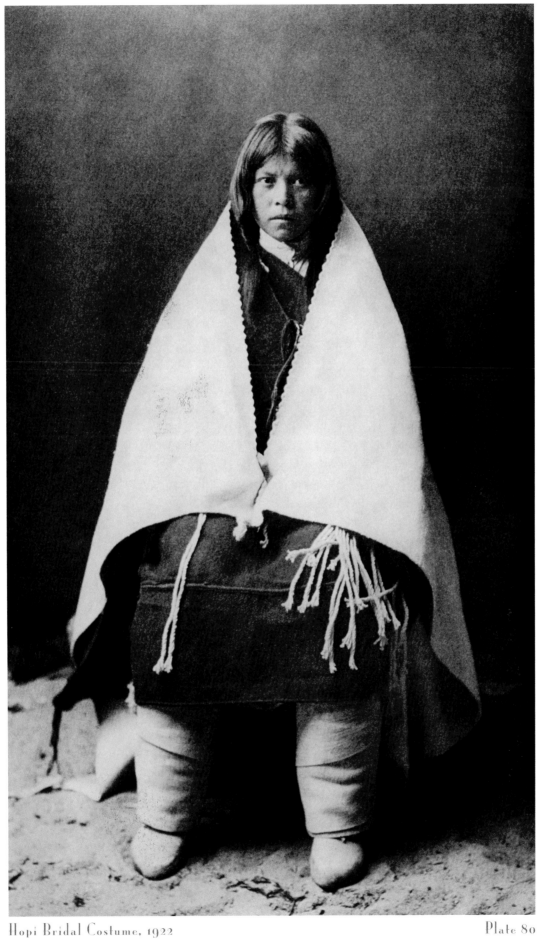

Hopi Bridal Costume, 1922 Plate 80

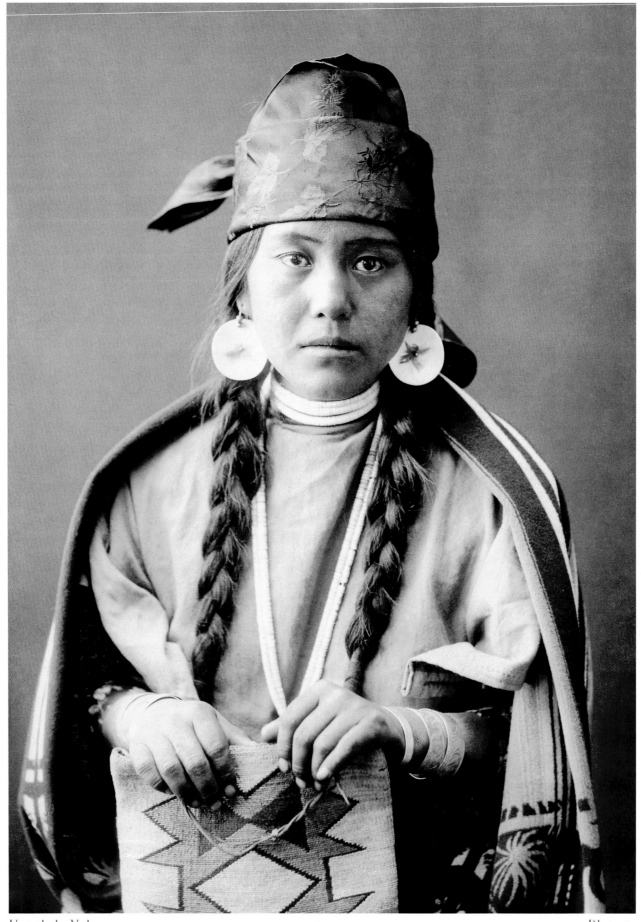

Untitled—Yakima

Plate 81

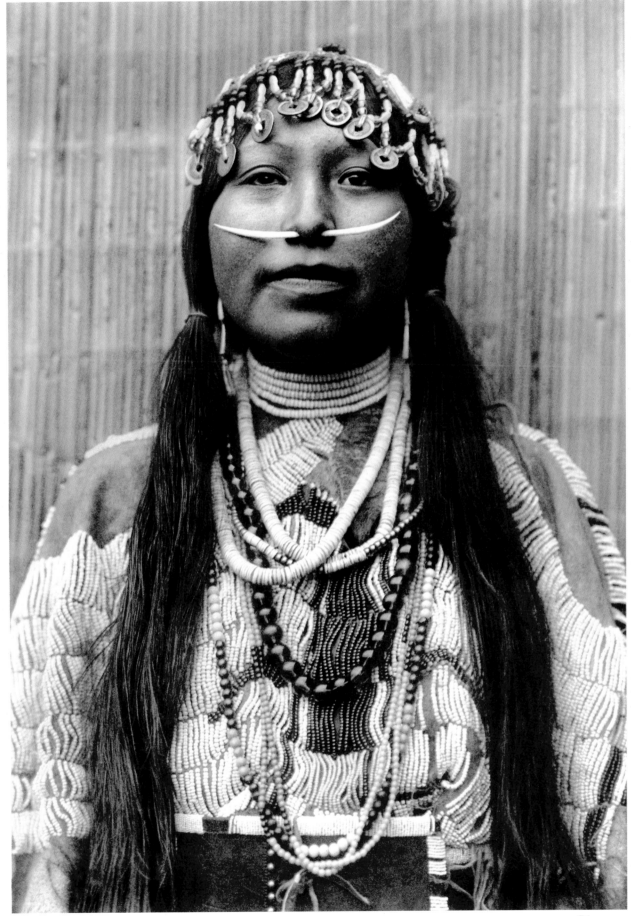

Wishham Girl, 1910 Plate 82

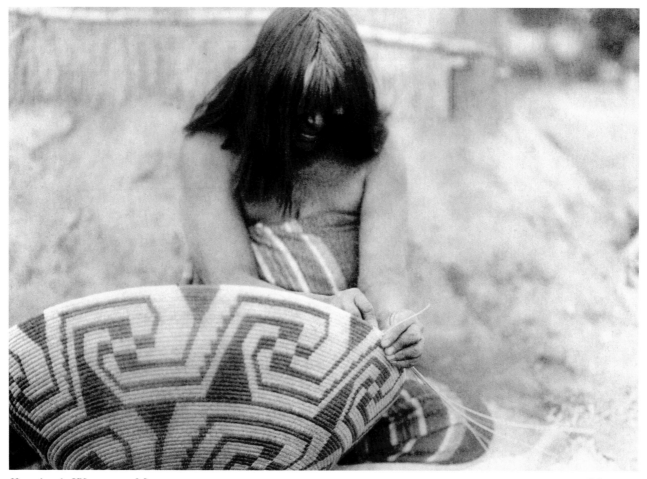

Havchach Weaving—Maricopa, 1908

Plate 83

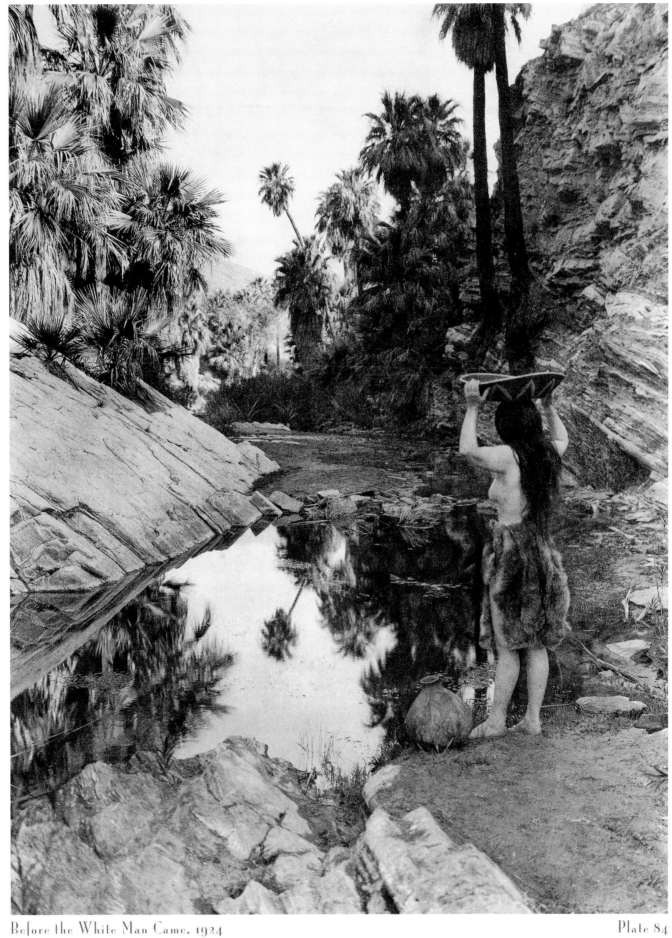

Before the White Man Came, 1924 Plate 84

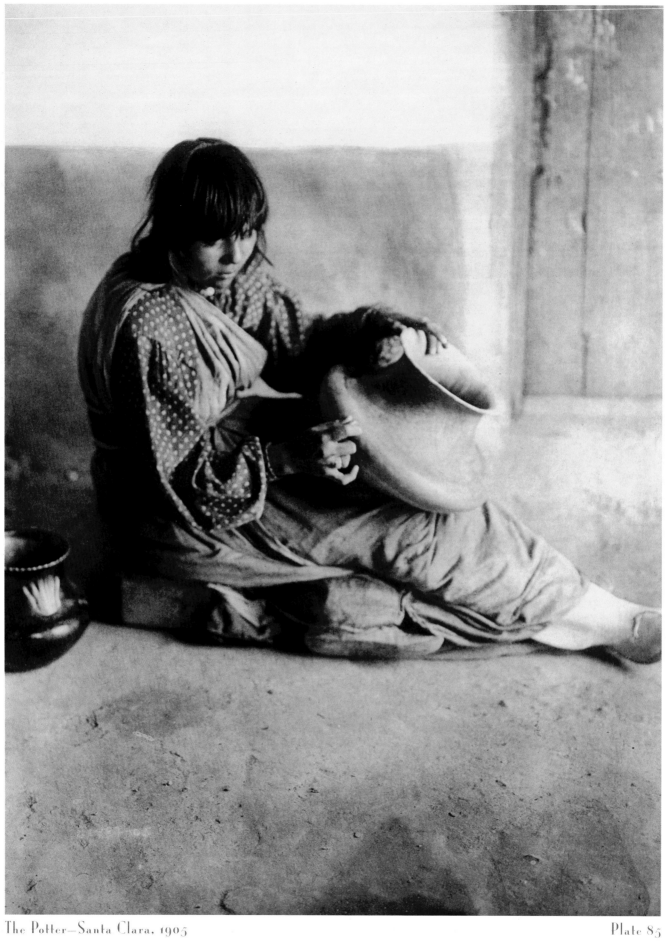

The Potter—Santa Clara, 1905 Plate 85

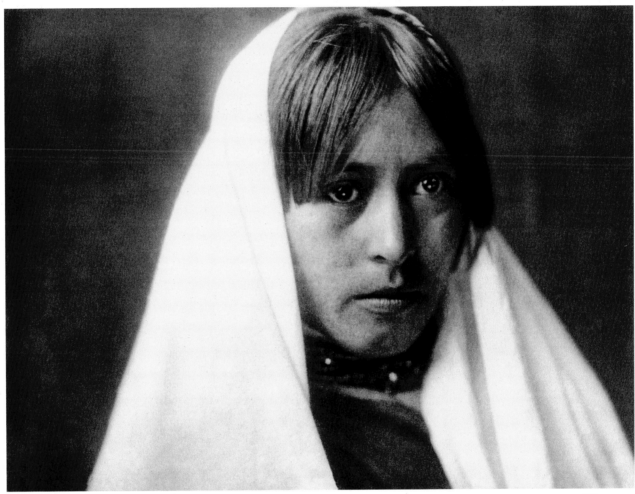

Walvia "Medicine Root"—Taos, 1905 Plate 86

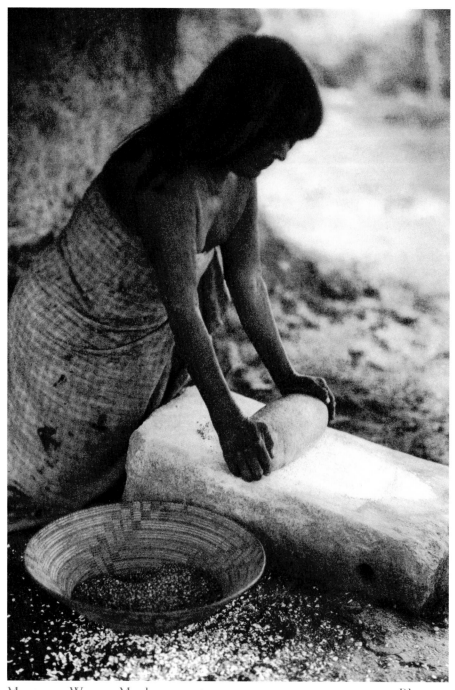

Maricopa Woman Mealing, 1908 Plate 87

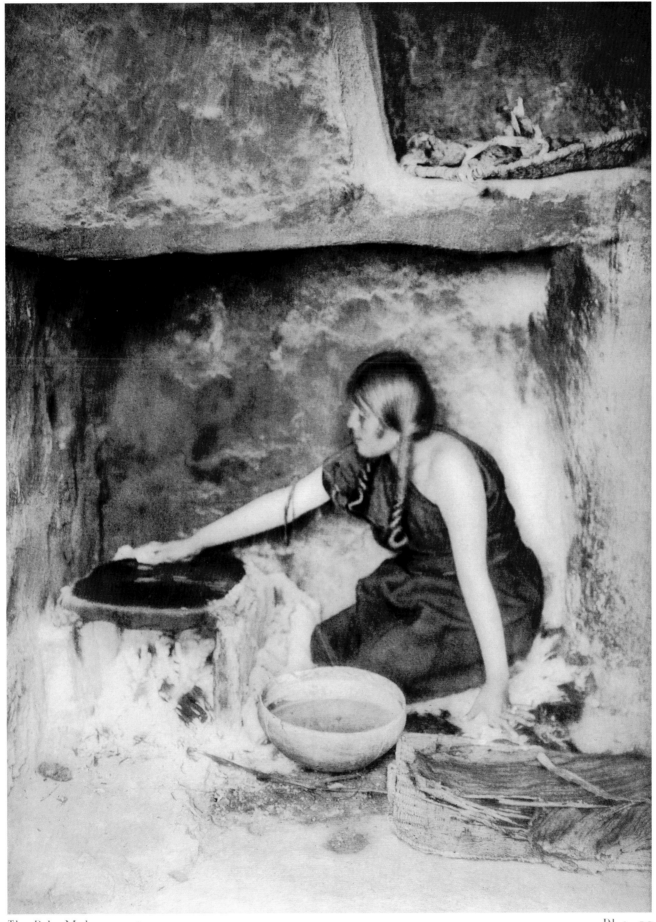

The Piki Maker, 1906

Plate 88

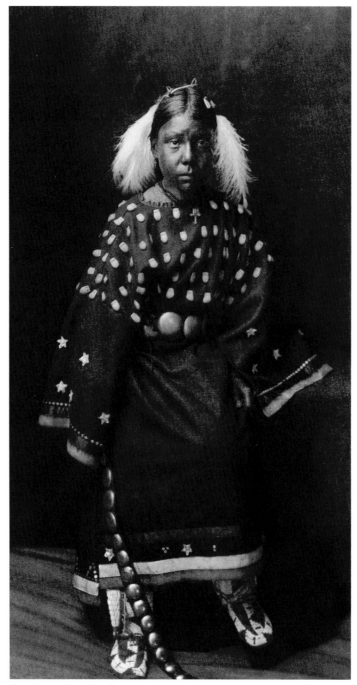

Ogalala Child—Sioux, 1908 Plate 89

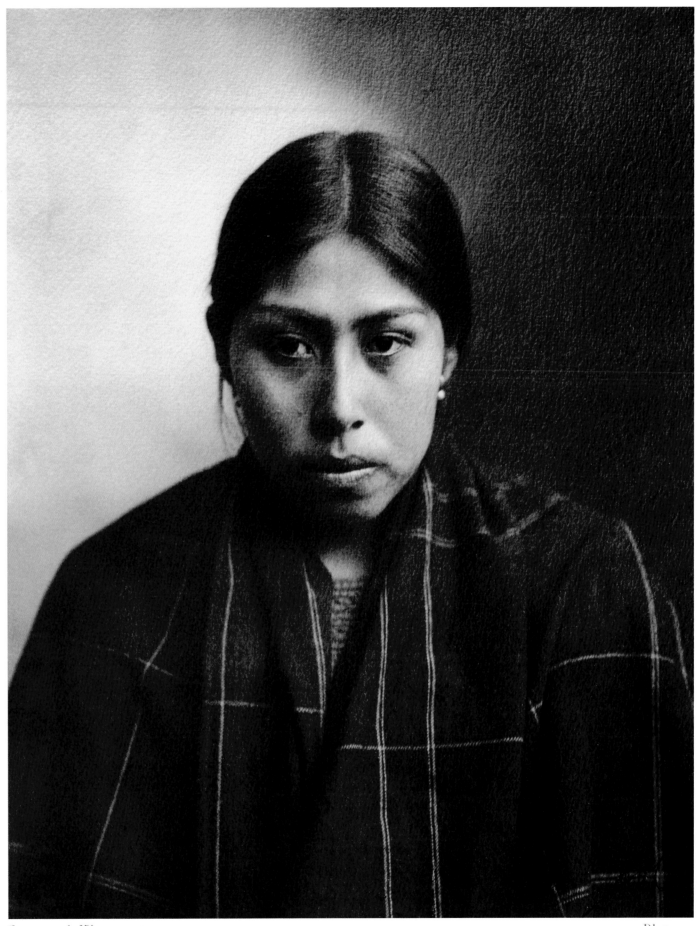

Plate 90

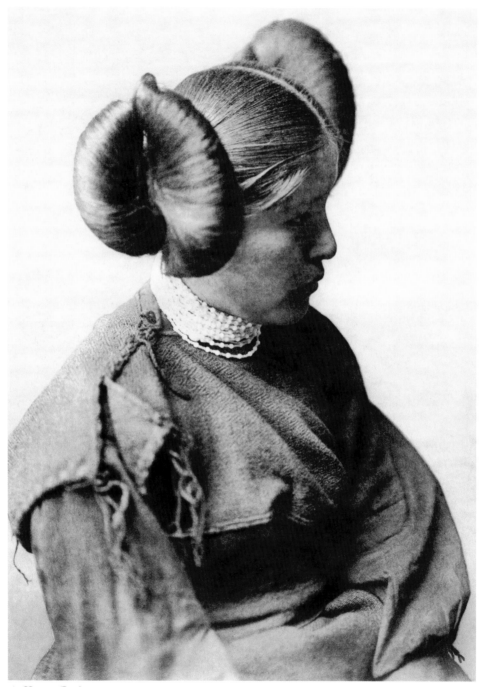

A Hopi Girl, 1905 Plate 91

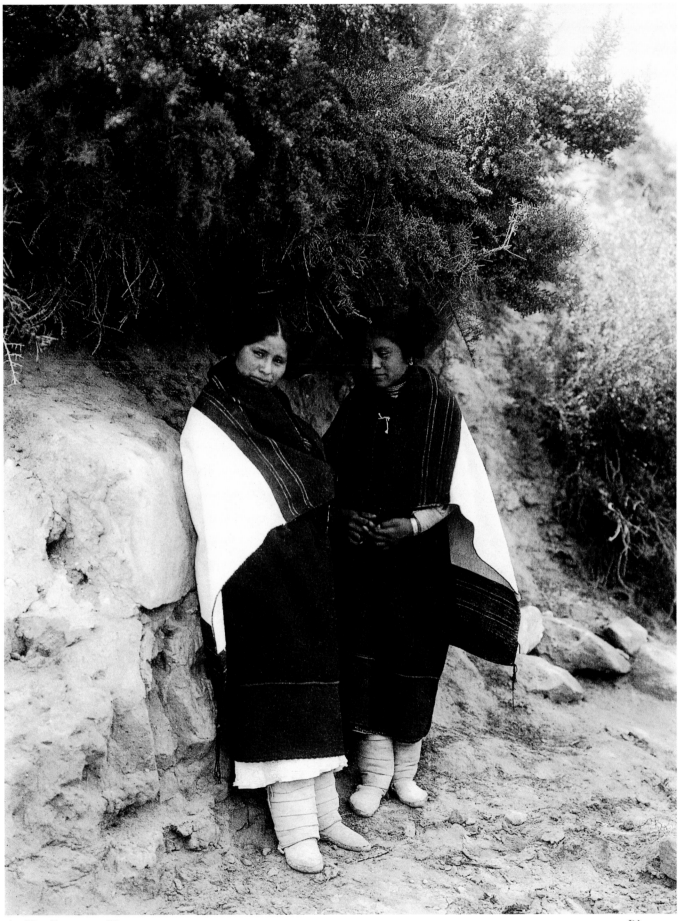

At The Trysting Place, 1921

Plate 92

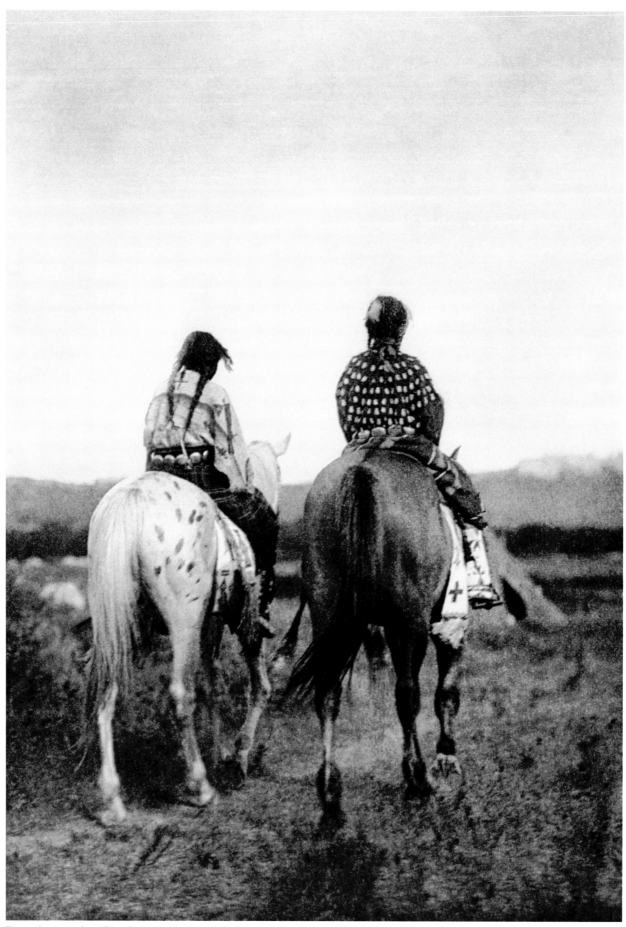

Daughters of a Chief, 1908

Plate 93

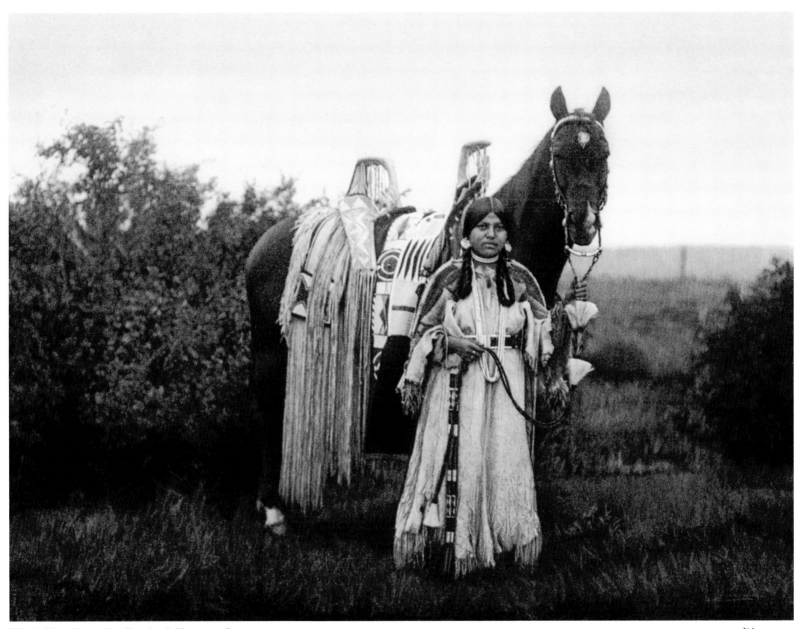

With Her Proudly Decked Horse—Cayuse, 1911

Plate 94

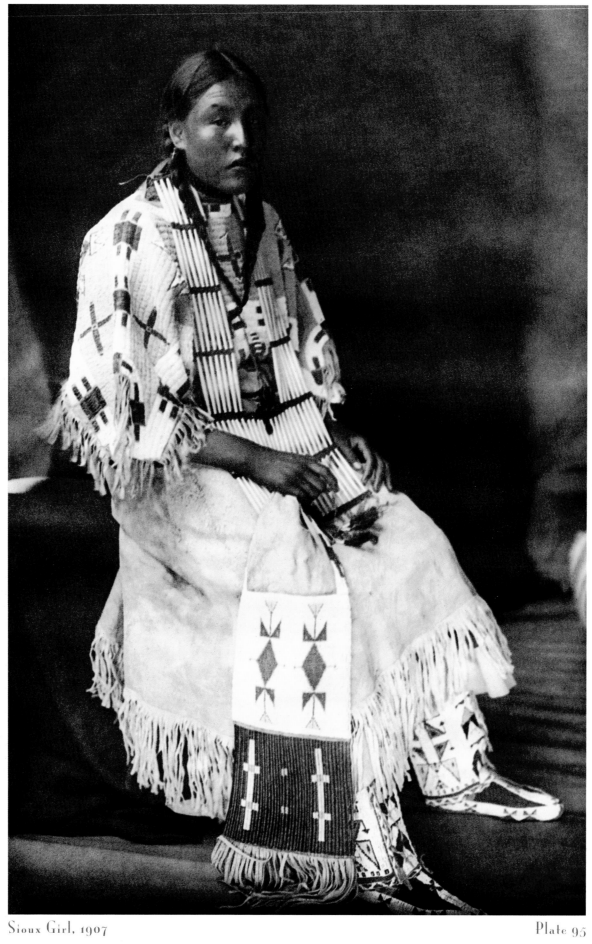

Sioux Girl, 1907

Plate 95

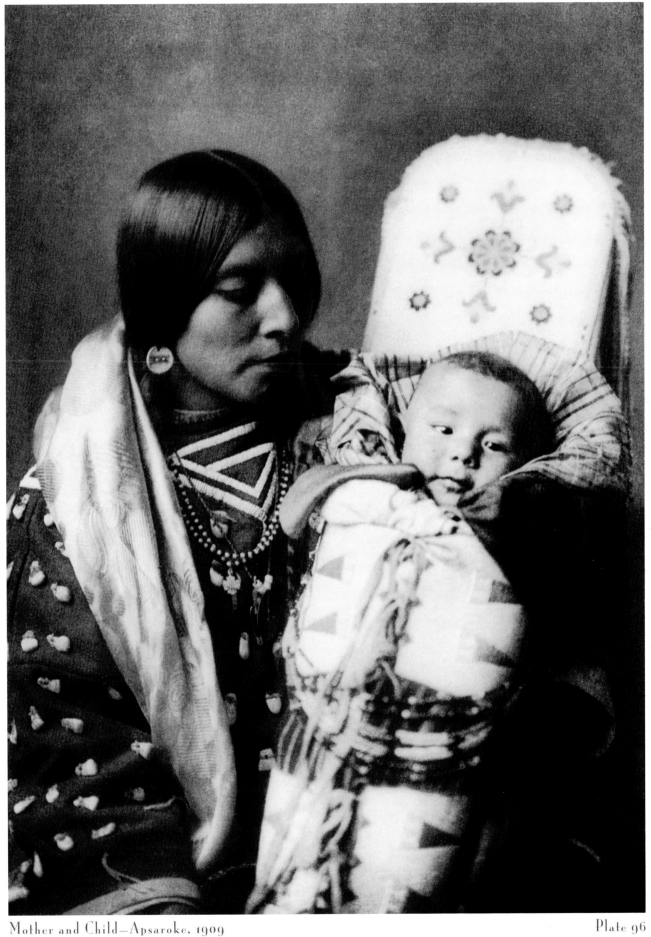

Mother and Child—Apsaroke, 1909

Plate 96

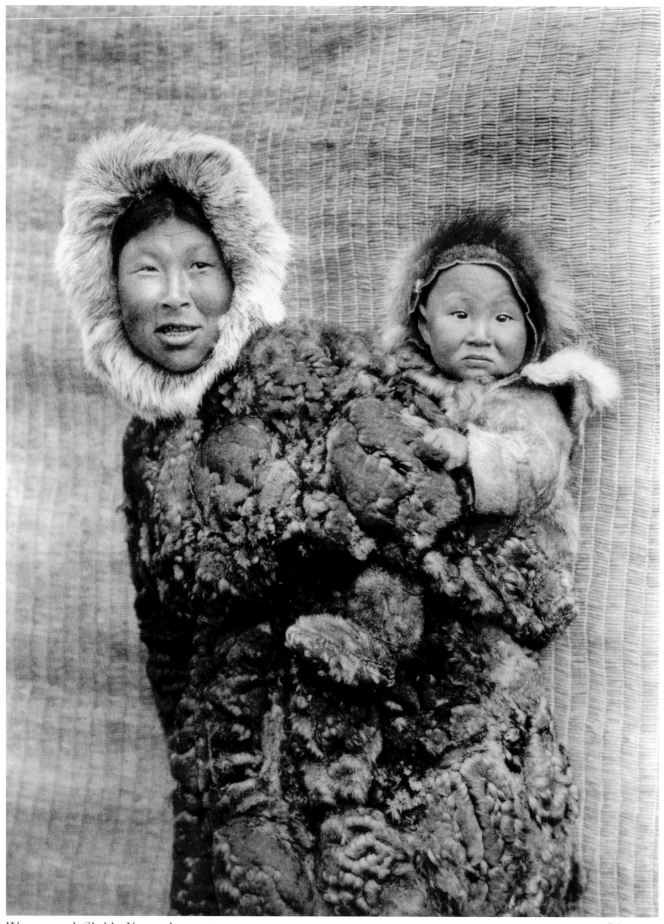

Woman and Child—Nunivak, 1928

Plate 97

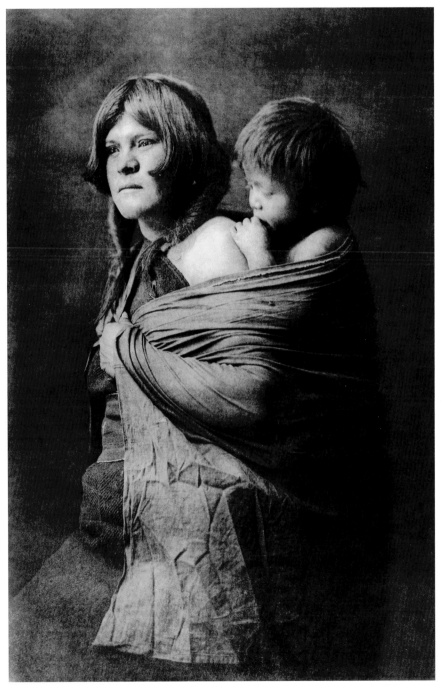

A Hopi Mother, 1921 Plate 98

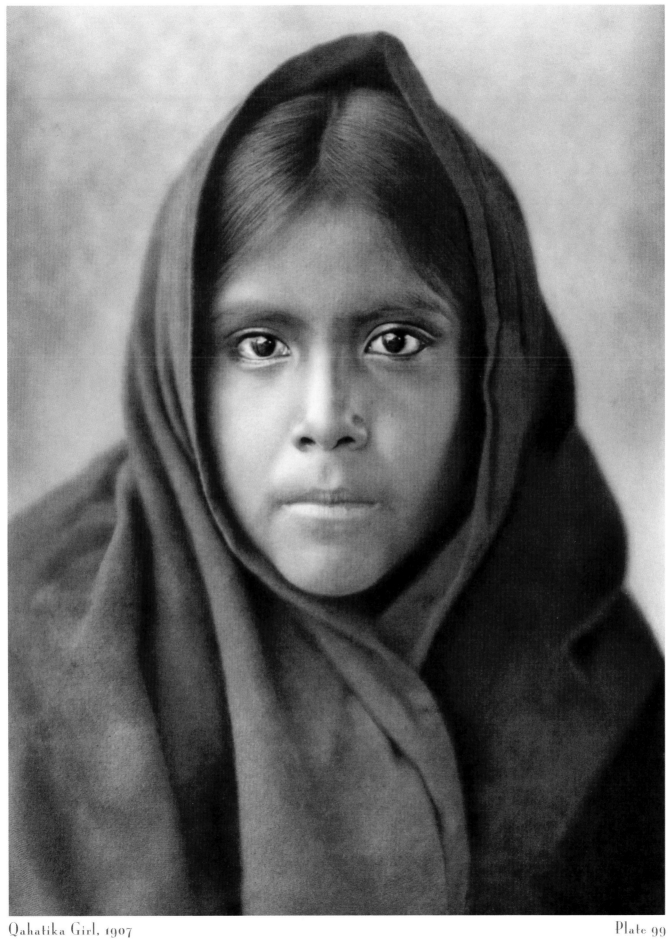

Qahatika Girl, 1907 Plate 99

This land is the house we have always lived in. The women, their bones are holding up the earth.

—Linda Hogan (Chicksaw)

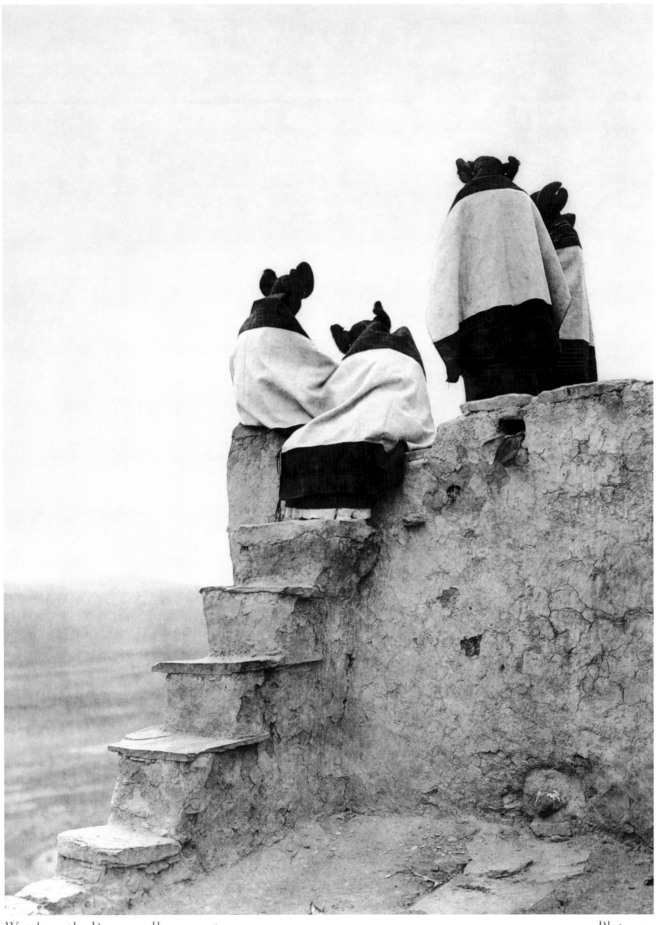

Watching the Dancers—Hopi, 1906

Plate 100

Plate List

Unless otherwise noted, all prints reproduced in this volume are from Curtis' magnum opus, *The North American Indian*, and were originally printed using the photogravure process. Descriptions are drawn largely from the writings of Edward S. Curtis.

Frontispiece - Winter–Apsaroke, 1908
See Plate 41.

Page 4-5 - Country of the Kutenai, 1910
Occasionally they made canoes of the form here illustrated, by stretching fresh elk-hides over a frame-work of fir strips or tough saplings. The one seen in the picture is a canvas-covered specimen found on the shore of Flathead Lake in 1909.

Page 6 - Princess Angeline, 1899
See Plate 60

Page 7 - The Mussel Gatherer, 1900
This famous photograph of Princess Angeline was taken in the Tidal Mud flats near Seattle.

Page 7 - The Clam Digger, 1899
Clams are an important food to those that live in the vicinity of the clam beds; to others they are comparative luxury obtained by barter.

Page 8 - Grinding Meal–Walpi, 1922
Hopi women and girls would gather in groups to visit while spending hours grinding corn.

Page 9 - The Piki Maker, 1906
See Plate 88.

Page 10 - At the Trysting Place, 1921
See Plate 92

Page 12 - Untitled (Curtis with Whale), 1914
Encouraged by great public hoopla and imbued with blind faith, Curtis did not foresee the unremitting sacrifices the project *The North American Indian* would exact from him.

Page 13 - A Hopi Mother, 1922
Photograph of a Hopi Mother and child is from one of Curtis' numerous visits to the Hopi nation where he became the first white man inducted into the Hopi snake priesthood.

Page 15 - The Wood Gatherer, 1908
This photograph of a Sioux woman is one of many Curtis took of Native American women engaged in their daily work. It is unusual, however, in that it's one of Curtis' small number of winter photographs.

Plate Page - Qahatika Water Girl, 1907
Qahatika handicraft shows considerable skill, particularly in pottery, many forms of which are made. All household utensils are of their own manufacture, besides which many small pieces are made for barter. Some examples are evidently copies of commercial ware, but many show true primitive feeling in form as well as in decoration.

Plate 1 - The Potter–Walpi, 1906
Every visitor at East Mesa knows Nampéyo, the potter of Hano, whose creations excel those of any rival. Strangers wander into her house, welcome though unbidden, but Nampéyo only works and smiles.

Plate 2 - Girl and Jar–San Ildefonso, 1905
Pueblo women are adept at balancing burdens on the head. Usually a vessel rests on a fiber ring, which serves to steady it and to protect the scalp.

Plate 3 - Klamath Woman–Klamath, 1923
The clothing of Klamath men and women consisted of a robe, moccasins, short leggings, and loincloth. Clothing was made of skin, usually that of a deer, or of woven tules, which sometimes were intermixed with feathers, held in place by pine pitch.

Plate 4 - Two Bear Woman–Piegan, 1911
When a girl was to be married she laid on her back, and the mother stretched a young boy on her for an instant. She would say, "Now you are to be married." This was done that the girl might not be frightened and resist the first approaches of her husband.

Plate 5 - Taos Water Girls–Taos, 1905
The young women in the photograph are carrying water back to their pueblo in beautiful traditional jars.

Plate 6 - At the Water's Edge–Arikara, 1909
Marriage was usually arranged by the families of the lovers, but the consent of the girl was always necessary. The relations of the young man went to those of the girl, and asked for her, agreeing to pay a certain stipend.

Plate 7 - Buffalo-Berry Gatherers–Mandan, 1909
As with many tribes, the work of preparing the soil and tending the crop was a task of the women, the men meanwhile performing the dangerous duty of keeping sharp lookout for Sioux and other Indians of hostile content.

Plate 8 - Untitled (Waiting for the Canoe)–Clayoquot, 1914
The Nootka tribes of Vancouver Island embrace a considerable number of tribes inhabiting favorable portions of the shores of the intricate fjords that cut deep into the island.

Plate 9 - Clayoquot Maiden–Nootka, 1916
Both Nootka sexes wore cedar-bark or fur robes pinned together at the right side, and women had in addition bark aprons extending from waist to knees. In rainy weather bark capes like a poncho were worn.

Plate 10 - Tlahleelis–Koprino–Kwakiutl, 1915
Of medium stature, the Kwakiutl are as a rule well formed and strongly built. The face is very characteristic, being usually high and with a prominent, frequently hooked, nose not found among any other North Pacific tribes.

Plate 11 - A Chief's Daughter–Nakoaktok, 1914
This chief's daughter was photographed bedecked as she would have been for a potlach ceremony. She is wrapped in hand woven cedar bark and an elegant hand-woven hat decorated with intricately carved pieces of abalone shell.

Plate 12 - Tsawatenok Girl–Tsawatenok–Kwakiutl, 1915
The winter village of the Tsawatenok formerly was Okunális at the mouth of Kwae [Gwáî], or Kingcome River. The summer locations were along the river. They now spend the winter at Kwaustums...on Gilford Island, a former Kocksotenok settlement.

Plate 13 - Lummi Type, 1899
The Lummi held considerable territory in the vicinity of Lummi Bay, Washington, as well as many of the San Juan islands.

Plate 14 - Apsaroke Mother–Apsaroke, 1909
On the fourth day after the birth of a child a man of prominence, or in some instances a woman, was called in to bestow a name, which, as a rule, was one that he had heard calling. Incense was made, and the child was raised four times in the cloud of smoke to symbolize the wish that it might grow tall and vigorous.

Plate 15 - Mother and Child–Sioux, 1908
When a child is born, the parents prepared a feast and sent for a wichásha-waká, asking him to name the infant. The name bestowed was always one suggested by some animal or object seen during one of his fasts, and the accompanying prayer was one taught him during a vision.

Plate 16 - In the Cradle-Basket–Hopi, 1922
Every fourth day the mother, the child, and the attendant have their heads washed with yucca suds. Not until the twentieth day can they use cold water. After that the mother's clanswomen take to the godmother a basket of meal and some mutton, which they have prepared on the previous day.

Plate 17 - Mohave Mother–Mohave, 1908
The Mohave spoke a language called Yuman. The population on the Colorado River reservation was a total of approximately 5,500 at the time Curtis photographed this tribe.

Plate 18 - Woman's Costume and Baby Swing–Assiniboin, 1928

The Assiniboin belong to the Siouxian stock. The popular name of this tribe is a Chippewa appellation signifying "stone cookers," referring doubtless to the custom of boiling meat with hot stones in bark vessels.

Plate 19 - Cayuse Mother and Child–Cayuse, 1911

The tradition says that these people occupied underground dwellings, which is the only indication of the primitive culture of the Cayuse.

Plate 20 - The Blanket Maker–Navaho, 1907

The handicraft of the Navaho is seen at its best in their blanketry, which is one of the most important industries of any Indian within our domain. The greater portion of the wool from their hundreds and thousands of sheep is used in weaving, and in addition a considerable quantity of commercial yarn is employed for the same purpose.

Plate 21 - A Zuni Girl–Zuni, 1903

Zuni is a substantial pueblo and in the late 1800's had multi-leveled terraced adobe dwellings reaching a full six stories in height. This Zuni Girl is in traditional clothing accentuated with extraordinary jewelry comprising ornate and complex silver, beadwork, and dentalium shells.

Plate 22 - At the Old Well of Acoma–Keres, 1904

Members of Coronado's army of explorers in 1540 and Espejo in 1583 noted the "cisterns to collect snow and water" on the rock of Acoma.

Plate 23 - Evening in Hopi Land–Hopi, 1906

The Hopi villages were established on their present almost inaccessible sites for purposes of defense; and with the same object in view the builders formerly never left a door in the outer walls of the first story. Access to the rooms was invariably through hatchways in the roof.

Plate 24 - Puliini and Koyame–Walpi–Hopi, 1922

The Hopi are without doubt among the most interesting of the surviving American Indians, and one of the very few groups recently living in a state similar to that of a hundred years ago.

Plate 25 - An Afternoon Chat–Walpi–Hopi, 1922

When a girl reaches the age of puberty she is sent to the house of a paternal aunt, where for three days, behind a curtain raised for the occasion, she grinds corn for her aunt. On the fourth day her head is washed with yucca suds by her aunt, who gives her a present and the girl then goes home.

Plate 26 - Untitled Mohave Woman, 1904

The Mohave principal diet was vegetal, including mesquite and screw-bean pods, various grass seeds, certain bulbous roots, and beans, and in later times watermelon and muskmelon.

Plate 27 - Untitled Mohave Woman, 1904

The primitive house, called avá, was built over a shallow circular excavation, nearly three feet deep, in which four posts were planted to support the roof timbers, which in turn supported the sloping wall poles. Three feet of the structure was above the surface, the measurement inside from floor to roof being somewhat less than six feet.

Plate 28 - The Whaler's Wife–Clayoquot–Nootka, 1916

The head of most the Nootka is round and full with large prominent checks and is frequently much depressed, or seems fallen in between the temples. The nose is flat at its base, with pretty wide nostrils, and a rounded point.

Plate 29 - Shaman and Patient, 1916

A ceremony called fsáyek by the Makah was performed when other means had failed to heal a patient. The members of the fraternity painted their faces red and wore cedar-bark headdresses.

Plate 30 - Hupa Female Shaman–Hupa, 1924

The upper part of the body was bare, except in cold weather. Hanging from a girdle about the waist was a knee-length fringe apron, made by stringing the shells of pine nuts on cords braided with grass. Tied about the waist was a deerskin skirt, open at the front so as to reveal the apron.

Plate 31 - Mohave Potter–Mohave, 1908

The weaving of skirts, rough willow burden baskets, pottery with rude conventional designs but of good form, and beadwork, constitute all the Mohave ever knew about the crafts and arts, and what little they once knew about basketry is now forgotten.

Plate 32 - The Potter Mixing Clay–Hopi, 1921

This woman, so aged that her shriveled skin hangs in folds, still finds pleasure in creating artistic and utilitarian pieces of pottery.

Plate 33 - Sigesh–Apache, 1903

This photograph illustrates the method employed by Apache girls for tying their hair previous to marriage. The ornament fastened to the hair in the back is made of leather and beadwork, and is broad and round at the ends and narrow in the middle.

Plate 34 - Kaktsamali–Cowlitz, 1913

No early writer gives us an adequate estimate of the Cowlitz population before strange diseases began their ravages.

Plate 35 - Untitled (Girl with Jar)–Hopi, 1900

Pottery and basketry are the work of women. Pottery vessels are built up by the process of coiling a rope of plastic clay upon itself, and are fired in a burning mound of sheep-dung. All cooking vessels, food dishes, and water-jars are pottery.

Plate 36 - Hano and Walpi Girls Wearing Atoo, 1922

Curtis' extraordinary love of these people, customs, and their land is obvious from the unusually large number of powerful photographs he made in the region.

Plate 37 - The Apache Reaper–Apache, 1906

Here the Apache woman is seen in her small wheat field harvesting the grain with a hand sickle, the method now common to all Indians of the Southwest.

Plate 38 - A Heavy Load–Sioux, 1908

Summer and winter the Sioux woman performed the heavy work of the camp, and what was seemingly drudgery was to her a part of the pleasure of life.

Plate 39 - Arikara Girl–Arikara, 1908

A type produced by several generations of tribal and racial intermarriage. The subject is considered by her tribesmen to be a pure Arikara, but her features point unmistakably to a white ancestor, and there is little doubt that the blood of other tribes than the one which claims her flows in her veins.

Plate 40 - Kutenai Woman, 1910

The creative instinct of the Kutenai women found expression chiefly in cedar-root basketry. A form of basket called Yichki, having its flat bottom, but with rounded edge, its sides flaring, and its rim a stout willow hoop for the attachment of the pack-string, served the purpose of a water-vessel.

Plate 41 - Winter–Apsaroke, 1908

In the thick forests along the banks of mountain streams the Apsaroke made their winter camps.

Plate 42 - The Blanket Weaver–Navaho, 1904

In the winter months blanket looms are set up in the homes, but during the summer they are erected outdoors under an improvised shelter, or, as in this case, beneath a tree. The simplicity of the loom and its product are here clearly shown pictured in the early morning light under a large cottonwood.

Plate 43 - Assiniboin Mother and Child, 1926

The Northern Assiniboin used the regulation Plains costume of deerskin clothing–shirt and hip-length leggings for men, dress and knee-length leggings for women, moccasins and robes for both sexes.

Plate 44 - Flathead Mother–Salishan, 1911

The clothing of both sexes was made in the common style of the plains. Much attention was bestowed on the hair. As a rule the women made a braid at each side, doubled it up, and wrapped it with strings of bone beads. They now allow the braids to land in front of the shoulder.

Plate 45 - Hidatsa Mother–Hidatsa, 1909

When a child was born the parents made a feast, and some prominent person, an old man or an old woman, was called in to give it a name. There was a ceremony connected with piercing the ears, a duty which the grandmother performed.

Plate 46 - Dusty Dress–Kalispel–Salishan, 1910

This Kalispel young woman, Skohlpa, is garbed in a dress ornamented with shells that imitate elk-tusks. The braids of hair are wound with strips of otter fur, and a weasel-skin dangles from each. The bands of white on the hair are affected with white clay.

Plate 47 - Spokan Woman—Salishan, 1911

From hearsay Lewis and Clark judged the population of the Spokan to be about six hundred, swelling in thirty houses, and Gibbs in 1853, estimated it as four hundred and fifty. Two years later, the number was eleven hundred, and in 1865 the Indian agent reported twelve hundred.

Plate 48 - Kího Carrier—Qahatika, 1908

The burden carrier, kího, is made of four pieces of the ribs of giant cactus meeting at a common point, where they are bound together, usually with a braided rope of human hair. The kího is carried on the back, supported by a band across the woman's forehead.

Plate 49 - Costume of a Woman Shaman—
Clayoquot—Nootka, 1916

Ösumich is the Calyoquot term for the process of purifying the body by washing and rubbing with hemlock sprigs in order to obtain special ability from supernatural beings.

Plate 50 - Tablita Woman Dancer—
San Ildefonso—Tewa, 1926

The aboriginal arts of basketry, pottery, and weaving are still practiced at San Ildefonso. Twined baskets for winnowing and washing grain and for gathering fruit are made of willow.

Plate 51 - Daughter of American Horse—Sioux, 1908

Dresses for other than the ordinary wear fringed at the bottom and under the sleeves, and ornamented with designs in quillwork. Earrings were pieces cut from clamshell, sometimes many of them in a string; massive ornaments made by stringing cylinders of bone were hung about the neck.

Plate 52 - Flathead Female Type—Salishan, 1911

The clothing of both sexes was made in the common style of the plains. Much attention bestowed upon the hair. As a rule the women made a braid at each side, doubled it up, and wrapped it with strings of bone beads. They now allow the braids to hang in front of the shoulders.

Plate 53 - Chinook Female Type—Chinook, 1911

A man of wealth had as many as eight wives. All lived in one house, the impartiality of the husband preventing discord, and the women were nominally equal, although a wife from a family of very high rank was naturally treated with deference and given more prominence in the presence of visitors.

Plate 54 - Kalasetsah—Skokomish—Salishan, 1913

Women wore a knee-length kilt of cedar-bark fringe. Some of the Puget Sound tribes used to a considerable extent deerskin clothing of the kind common to the plains Indians—shirt and leggings for men and one-piece gown for women.

Plate 55 - Primitive Style of Hair Dressing
(Variant), 1921

The Hopi are divided into twelve clans, which, however, are not all represented at any one village. Each clan possesses totems, or name objects, which most commonly are either animals, plants, or natural phenomena.

Plate 56 - Coast Pomo Bridal Costume—Pomo, 1924

The Pomo are one of the best-known groups of California Indians known for their highly developed skill in the art of basketry. They controlled fully half of the area of Mendocino, Sonoma, and Lake counties, and a small detached territory in Glenn and Colusa counties.

Plate 57 - Atsina Maiden—Atsina, 1909

In courting, young men went about in the evening wrapped completely in buffalo-robes. If a prospective bride refused, negotiations were opened between the two families, that of the man taking the initiative. The value of the gifts offered, and the ability of the young man as a hunter and warrior, were desiderata.

Plate 58 - The Chief Had A Beautiful Daughter—
Apsaroke, 1909

The chief had a very beautiful daughter. Handsome young men, brave warriors and good hunters, wooed her, but she gave them no encouragement. Neither the greatest deeds in battle not lavish bestowal of presents could soften her heart.

Plate 59 - Wishham Female Type—Wishham, 1911

The walls of the permanent houses were constructed of split cedar slabs placed upright around a rectangular framework of forked posts and horizontal connecting timbers. Inside, the ridge-roof was formed of pole rafters and thatching of cedar bark and rush matting, and a smoke-vent was provided in the center.

Plate 60 - Princess Angeline, 1899

Chief Seattle's daughter, believed to be Curtis' first Native American subject.

Plate 61 - Mosa—Mohave, 1903

It would be difficult to conceive of a more thorough aboriginal than this Mohave girl. Her eyes are those of the fawn of the forest, questioning the strange things of civilization upon which it gazes for the first time.

Plate 62 - Hipa—Mohave, 1909

Primitively the dress was entirely of willow bark cloth with women wearing a skirt reaching from waist to knees. The women have always worn the hair hanging loosely, but cut a trifle shorter than that of the men.

Plate 63 - Pele—Tewa, 1922

Women formerly wore the mötsapú, an undyed cotton robe, which passed under the left arm and over the right shoulder, but not at the side. Ordinarily nothing else was worn, only on ceremonial occasions, such as dances and weddings, did women use the one-piece moccasin with pure white leggings attached.

Plate 64 - A Hopi Woman (Unpublished Variant)

The Hopi terms of measurement are quite simple. The measurement of the outstretched thumb and middle finger is called t_kyélemi; from tip to tip of the middle fingers with the arms outstretched is called máhmki. The term used in measuring land or distance is Iílaki.

Plate 65 - Kalispel Maiden, 1911

The Kalispel women made robes of strips of fur from the muskrat, the beaver, and the otter. Through several generations of youthful marriages and too close inbreeding the people have degenerated into a band of undersized weaklings.

Plate 66 - Quinault Female Type—Salishan, 1913

The Quinault were less migratory than many of the tribes of the north Pacific Coast, who in search for food annually abandoned their permanent villages in the summer. Women and slaves gathered berries and roots in near places, and never remained more than a day or two away from home.

Plate 67 - Typical Spokan Woman, 1911

In 1870 a Government inspector took a census of the tribes in Washington and returned with a Spokan population of 716. Information about the dress, dwellings, games, foods, marriage, religion and burial are all told as the group of Salishan with 12 smaller tribes creating the Salishan.

Plate 68 - Hopi Bridal Costume (Variant)

The night after a wedding feast the couple spend a room apart from the bridegroom's family, and there they live until his relatives have made for his wife two cotton blankets, a marriage belt, and a pair of deerskin moccasins and leggings, which requires about ten days.

Plate 69 - Sia Street Scene—Keres, 1925

Sia is situated on the north bank of Rio Jemez, a few miles below Jemez pueblo. Ancient Sia, having participated in the revolt of 1680, was completely destroyed along with most inhabitants by Governor Domingo de Cruzate in 1689.

Plate 70 - Embarking—Kutenai, 1910

Inhabiting a mountainous country dotted with lakes and traversed by long winding rivers, the Kutenai very naturally became expert boatmen. The more common form of craft was a canoe made of pine-bark or spruce-bark laid over a framework of split fur. It was sharp at bow and stern, of the form still seen among the Kalispel.

Plate 71 - Country of the Kutenai, 1910

The more common form of canoe was the pine-bark craft still to be observed among the Kalispel, but occasionally they made canoes of the form here illustrated, by stretching fresh elk-hides over a framework of fir strips or tough saplings.

Plate 72 - The Rush Gatherer—Kutenai, 1910

Rushes gathered in the swamps and in the shallows of the lakes were dried and strung together into mats, which primitively were used for lodge-covers, mattresses, canoe cushions, and for a variety of domestic purposes.

Plate 73 - Untitled (Nampéyo Painting)—Hopi, 1900

The most successful imitator of the ancient ware, who is not a Hopi at all, but the Tewa woman Nampéyo, of the village Hano, says that its superiority was obtained by the use of lignite, by which the prehistoric potters were able to fire their vessels for several days.

Plate 74 - Pomo Mother and Child—Pomo, 1924

Pomo clothing was of the simplest kind; in fact, the men ordinarily were stark naked. Women wore short kilts of shredded tules, which hung in a thick mass of fringe about the thighs. Sometimes the skirt was made of deer-skin or cougar-skin, and among the Coast Pomo shredded redwood-bark was common. Hats were unknown, and feet and legs were habitually bare.

Plate 75 - Tenokai—Apache, 1907

Both skirt and waist were ornamented with deerskin fringe and latterly with metal pendants. They did not braid their hair but let it hang loosely over the shoulders. The maidens tie their hair in a low long knot at the back of the head, to which is fastened a decorated deerskin ornament, denoting maidenhood.

Plate 76 - Nootka Woman Wearing Cedar-Bark Blanket, 1915

An infant's ears were pressed down on a block of wood, and man whose profession it was to pierce struck then struck the ear with an eagle wing-bone sharpened like a harness-maker's punch.

Plate 77 - Povi-Tamu ("Flower Morning"), 1905

The flower concept is a favorite one in Tewa names, both masculine and feminine. The regular features of the comely Morning Flower are not exceptional, for most Tewa girls, and indeed most Pueblo girls, are not without attractiveness.

Plate 78 - Povi-Tamu ("Flower Morning"), 1905

See Plate 77.

Plate 79 - Hidatsa Woman, 1909

The dress reached to the ankles, and the fringe and deer-hoof rattles at the bottom swept the moccasins. At the shoulders the sleeves were decorated with porcupine quills, and as with many tribes they were left open under the arms for the convenience of nursing.

Plate 80 - Hopi Bridal Costume, 1922

The Hopi are monogamous. An exchange of food between the two interested families is made as a pledge of marriage, and the subsequent wedding rites extend over four days. The couple remains at the husbands' home until his relatives have completed the bride's wedding garments, and thereafter reside with her people.

Plate 81 - Untitled - Yakima

Their finest baskets were coiled cedar roots stitched together with the outer shreds of the roots, and with imbricated ornamentation of bear-grass, which was left white, as in its natural state, or was dyed black by immersion in blue clay, or yellow by boiling in water with certain berries.

Plate 82 - Wishham Girl, 1910

The subject is clothed in a heavily beaded deerskin dress of the plains type. The throat is encircled by strands of shell beads of native manufacture, heirlooms, which were obtained by the original Wishham possessor from the Pacific slope. Pendant on the breast are strands of larger beads of the same kind.

Plate 83 - Havchach Weaving—Maricopa, 1908

The dress of the women formerly consisted of a piece of this cloth wound around the body under the arms and reaching to the knees, with an outer shawl for cold weather.

Plate 84 - Before the White Man Came, 1924

Palm canyon is at the eastern base of San Jacinto mountains on Agua Caliente reservation, which is one of several areas occupied by Cahuilla. The locality is well known under the name of Palm Springs.

Plate 85 - The Potter—Santa Clara, 1905

The potter is polishing a vessel. The smooth pebbles used for this purpose are found in small heaps among or near deposits of fossil bones. They are the stomach pebbles of dinosaurs. Tewa women prize them highly, refuse to part with them, and foresee ill luck if one is lost.

Plate 86 - Walvia ("Medicine Root")—Taos, 1905

Walvia is a characteristic type of Taos womanhood.

Plate 87 - Maricopa Woman Mealing, 1908

The Maricopa are a sedentary, agricultural people. The principle crop of their small irrigated farms is wheat, which they grind into a course flour on the metate, or hand mealing stone.

Plate 88 - The Piki Maker, 1906

Piki is corn-bread baked in colored sheets of paper-like thinness. The batter is spread on the baking-stone with the bare hand, and the quickly baked sheet is folded and laid on the basket at the baker's left.

Plate 89 - Ogalala Child—Sioux, 1908

The Lakota, or Teton Sioux, during early historic times occupied the region about Big Stone Lake, in western Minnesota, whence they moved gradually westward, driving the Omaha to the Southwest and themselves occupying the valleys of the Big Sioux and the James in South Dakota. Making their way still westward, they reached the Missouri, forcing the Arikara southward and penetrating as far as the Black Hills.

Plate 90 - Suquamish Woman, 1899

The tribes of the Northwest Coast had the most elaborate and sophisticated material culture of any Curtis visited. He felt that, of all cultures he had encountered, the peoples and customs he found there were the least tainted by European influence.

Plate 91 - A Hopi Girl, 1905

Soft, regular features are characteristic of Hopi young women, and no small part of a mother's time used to be devoted to dressing the hair of her unmarried daughters. The aboriginal style is rapidly being abandoned, and the native one-piece dress here illustrated is seldom seen even at the less advanced of the Hopi pueblos.

Plate 92 - At the Trysting Place, 1921

Hopi myths are largely a recital of the circumstances under which various religious practices were instituted among the ancients by supernatural beings, of the contests of sorcerers against upright persons, who invariably win by the aid of the super naturals, of the activities of the wonder-working war gods.

Plate 93 - Daughter's of a Chief, 1908

The dress of the women consisted of a garment made of finely tanned deerskins, which extended from the shoulders to midway of the knee and ankle. A dress regarded as well-made was fringed at its bottom and sleeves, and finely decorated at the shoulders and arms with porcupine quills, beads, and shells.

Plate 94 - With Her Proudly Decked Horse—Cayuse, 1911

The Cayuse were a sullen, arrogant, and warlike people. Of alien speech, they were on such intimate terms with the Shahaptian tribes of that region that in 1851 their language was becoming obsolete, and for many years there has been none who could speak.

Plate 95 - Sioux Girl, 1907

This young Sioux woman is in a dress made entirely of deerskin, embroidered with beads and porcupine quills, as is the unusually large pipe bag she is holding. Her moccasins and leggings are also evidence of intensely detailed beadwork. Among all of Curtis' female portraits this is one of the most beautifully costumed.

Plate 96 - Mother and Child—Apsaroke, 1909

The rigors of life in the Rocky Mountain region made the women as strong as the men; and the women who could carry a quarter of a buffalo apparently without great exertion, ride all day and all night with a raiding war-party, or travel afoot two hundred and fifty miles across an unmarked wilderness of mountains, plains, and swollen streams in four days and nights, were not the women to bring forth small offspring.

Plate 97 - Woman & Child—Nunivak, 1928

Both sexes wear the parka, a frock-like garment reaching to the knees. The pattern is similar for both men and women, excepting that there is an open seam on the bottom of each side of hem of the women's parka. Parkas are made of bird-skins or animal skins.

Plate 98 - A Hopi Mother, 1921

Ordinarily the only garments of the primitive Hopi woman were an undyed cotton robe, which passed under the left arm and was fastened above the right shoulder, the edges overlapping at the right side, and an embroidered belt. Arms and lower legs were bare.

Plate 99 - Qahatika Girl, 1907

About forty miles due south of the Pima reservation, in five small villages, one sees a type of the true desert Indian—the Qahatika. When or why they separated from their Pima kindred and wandered into this inhospitable desert is a question on which even tradition is vague.

Plate 100 - Watching the Dancers—Hopi, 1906

A group of girls on the topmost roof of Walpi, looking down into the plaza.

About the Author

Christopher Cardozo is widely acknowledged as one of the world's leading authorities on the work of Edward S. Curtis. Cardozo first came upon Curtis' photographs in 1973 after returning from an eight-month photographic journey to a small, isolated Mexican Indian village. Many of the people he visited had seen few (if any) whites, and many had never seen a photograph. Cardozo created an extensive body of work, making sepia-colored portraits and landscapes. After returning to the United States, he was shown a recently published book on Curtis. This first encounter with Curtis' work was a watershed experience and Cardozo began a thirty-year odyssey that has included collecting, researching, writing, lecturing, curating, publishing, and operating the most active Curtis gallery in the country for over a decade. Cardozo's own photographs of Mexican Indians have been widely exhibited and examples are in various museum collections, including the Museum of Modern Art in New York.

Cardozo has authored seven previous books on Curtis and his unique personal Curtis collection is described below. Cardozo also founded the Edward S. Curtis Foundation, which is dedicated to cultivating an awareness and appreciation of Curtis and his work, and has begun to explore possibilities for creating a Curtis museum. In addition to his B.F.A. in photography and film, Cardozo is trained as a lawyer and has lectured on art law. He is based in Minneapolis and has recently retired as a gallery owner to concentrate on his activities as a collector and private dealer, and once again to focus on his own artistic career and contemplative studies.

About the Collection

All photographs reproduced in this book are from the personal collection of Christopher Cardozo. He began collecting Edward Curtis' photographs thirty years ago, within hours of seeing his first original Curtis print. Since then, Cardozo has added over 4,000 vintage Curtis photographs to the collections, as well as hundreds of related objects and documents. The prints range from rare and/or unique prints that Curtis made, such as field prints, reference prints, experimental prints, special exhibition prints, etc., to the better known photogravures. In all, the collection contains examples of Curtis' work in at least seven different media. Additionally, Cardozo has collected Curtis' original negatives, a camera, his wax cylinder sound recorder, business records, studio portraits, lecture notes, and promotional materials. In total, his collection comprises nearly 4,500 photographs and related objects, and is the largest and most broad-ranging Curtis collection in the world. In drawing from this collection to create this book, Cardozo sought to bring many previously unpublished images to light, as well as to pay special attention to creating a strong and effective sequencing of images, which, coupled with powerful juxtapositions, is intended to enable the viewer to fully appreciate the beauty of Curtis' photographs.

Acknowledgments

I wish to thank Gary Chassman of Verve Editions for his unflagging efforts in the realization of this book, as well as Anne Makepeace and Louise Erdrich for their gracious contributions. I particularly want to thank both Peter Bernardy and Erica Gilbert for their dedication, long hours, and support. I would also like to acknowledge Bulfinch Press and editor Michael Sand for their faith and commitment, without which this volume would not exist. Designer Stacey Hood's contributions are apparent throughout the book. For further information on the purchase of Edward S. Curtis vintage or contemporary photographs, licensing rights, Curtis exhibition rentals, or for information on the current international museum tour of vintage Curtis photographs, including exhibition highlights and schedule, contact us at www.edwardcurtis.com or 888-328-7847.

Bulfinch Press

Time Warner Book Group
1271 Avenue of the Americas, New York, NY 10020
Visit our Web site at www.bulfinchpress.com

First Edition

ISBN 0-8212-2895-1

Library of Congress Control Number 2004116712

Developed and produced by Verve Editions and Christopher Cardozo, Inc.

Design by Stacey Hood

PRINTED IN ITALY